CRAMOND

THROUGH TIME

John Dods *&* William Scholes

AMBERLEY PUBLISHING

First published 2012

Amberley Publishing
The Hill, Stroud
Gloucestershire, GL5 4EP

www.amberley-books.com

Copyright © John Dods & William Scholes, 2012

The right of John Dods & William Scholes
to be identified as the Authors of this work
has been asserted in accordance with the
Copyrights, Designs and Patents Act 1988.

ISBN 978 1 84868 617 5

British Library Cataloguing in Publication Data.
A catalogue record for this book is available from
the British Library.

Typeset in 9.5pt on 12pt Celeste.
Typesetting by Amberley Publishing.
Printed in the UK.

Introduction

The parish of Cramond was formerly more extensive. From Cramond village and the mouth of the River Almond the ancient parish reached along the shore to Granton in one direction, and to part of Dalmeny estate in the other. It included Cramond Island and areas such as Craigleith, Blackhall, Ravelston, Craigcrook, Davidson's Mains and Craigiehall. The southern boundary stretched as far as Turnhouse, creating an area of some 12 square miles. Many of the early images in this book, albeit only from the late nineteenth or early twentieth centuries, reflect the wider application of the name of Cramond.

While the changing times have affected Cramond, they have not significantly changed its atmosphere. It still retains something of its earlier character. From the seventeenth century prestigious houses built within the parish had marked it out as a desirable place in which to reside, or to receive and impress visitors. By the beginning of the twentieth century, holiday cottages were rented near the sea, people came to Cramond to 'take the air', and even today on a fine day the promenade is crowded with visitors – walking, jogging, cycling, or skateboarding – while young families picnic or build sandcastles on the beach. The panorama beyond the Firth of Forth to the Kingdom of Fife is as superb as it always was.

Over the centuries, Cramond's historic kirk has served as a symbol of continuity. Built on the headquarters of a Roman fort, worship is said to have been conducted on the site from the sixth century, and the very stones chiselled by the Romans have been built into its walls. It is fitting that this journey around the parish begins here. Historically the owners of the many fine properties in the parish were legally obliged to maintain the kirk. These associations raised the standing of Cramond's place of worship, which was once an arbiter of morality and social conduct, a dispenser of charity, and responsible for education.

From the area of the church the photographic journey moves to the harbour and the River Almond, where there is evidence of industrialisation in the form of ironmills and dwellings for their workers. Away from the river, farming served as an occupation for many of the residents, whether as ploughmen, dairymen, or farm servants. Now the footprint on the land is not of cattle or crops, but of townhouses, villas, apartments and retirement homes. The big houses too once gave rise to occupational roles such as coachman, butler, housekeeper, governess and domestic servant, and for a period the quarrymen in the parish supplied stone for the demands of the City of Edinburgh.

As well as social and structural changes, different modes of travel can be traced, from pilgrims on foot crossing the River Almond by the centuries-old ferry towards St Andrews, to the horse and cart, and finally to the ingress of the railway system and the motor vehicle. The last two brought ready access to the parish from the city, which resulted in a period of building of desirable private residences and select golf courses. However the demand for an improved road system resulted in the bypassing of the traditional route through Davidson's Mains and Cramond's ferry to the Queensferry and over the Forth. Cramond's Auld Brig, built in the fifteenth century and jointly repaired by the shires of Edinburgh and Linlithgow, stood aside as a witness as Rennie's eight-arched bridge of 1823 replaced it, only to be blown up in 1962 to make way for a four-lane highway. Speedy progress, traffic build-ups apart, was thus ensured northwards to the Forth Road Bridge, opened by Queen Elizabeth in 1964. Cramond slumbered for a brief moment as the world passed it by, until the Secretary of State for Scotland decreed in 1973 that the air corridor in to Edinburgh Airport would be over Cramond.

The recent discovery by the ferryman of a Roman funerary lioness imbedded in the mud of Cramond's harbour at low tide, where it had lain for almost 2,000 years, brought worldwide attention to the area. Now, the medieval ferry itself is no more, the victim of new legislation. However there is a vision to restore the river crossing to Dalmeny estate by means of a chain ferry. And so the changing story of Cramond goes on through time.

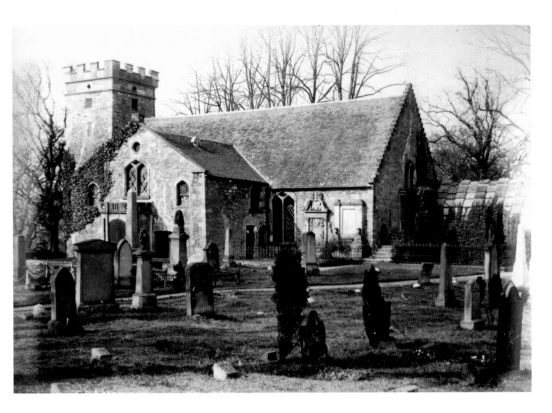

Cramond Kirk – Ancient and Modern

Documentary evidence dates a church presence in Cramond from at least the thirteenth century, dedicated to St Columba and linked to the abbey on Inchcolm. Prior to 1911 the main entrance was from the east and the building was in a state of disrepair. All but the tower was demolished and the restoration of 1911/12 brought a fourth, north gallery which extended the capacity of the church and altered the main entrance to the west.

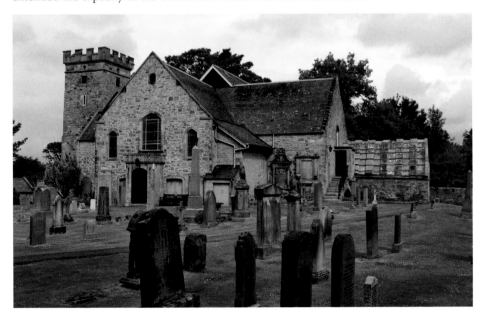

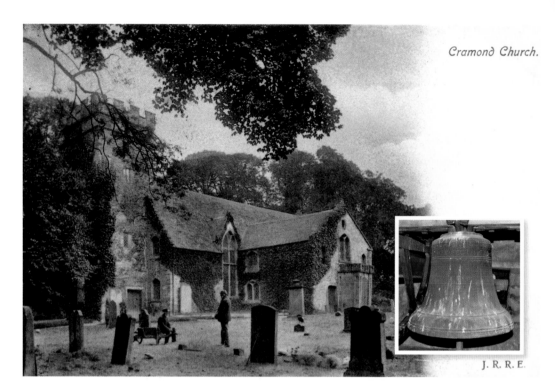

J. R. R. E.

Cramond Kirk's Links with a Turbulent Past

The fifteenth-century kirk tower remains as evidence of earlier origins and contains the Dutch bell, plundered by the Ironside troops of Oliver Cromwell but later returned. The early records of the kirk session were also carried off but not returned. However there is a complete record from 1651. The tower door formerly gave private entry to the gallery of Lord Rosebery and the other to the Maitland family of Barnton House, Cramond's main heritor.

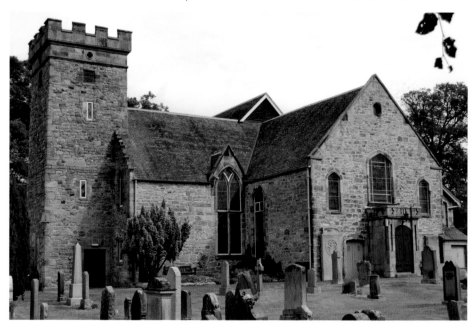

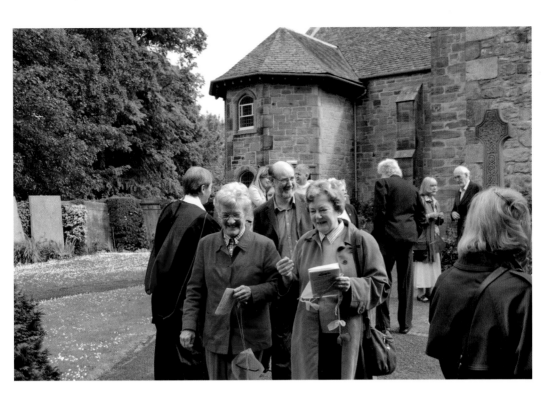

Cramond Kirk After Restoration and Enlargement

The new and the old merge as the twenty-first-century congregation leaves the church via the century-old extension of the north gallery. Internally the structure of the church has remained as per the design of James Mather of 1911. Pitch pine was used for the roof and Oregon pine for the pews. Queen Victoria worshipped from the Cramond gallery on the left. Ahead is the Barnton gallery (Maitland family), and the Dalmeny gallery (Rosebery family) is to the right.

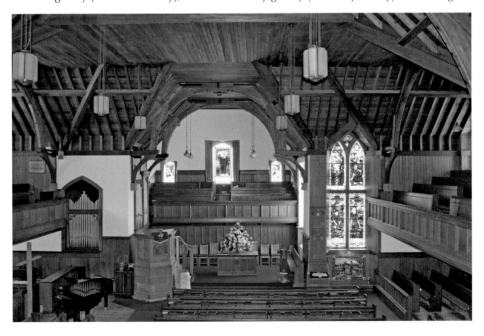

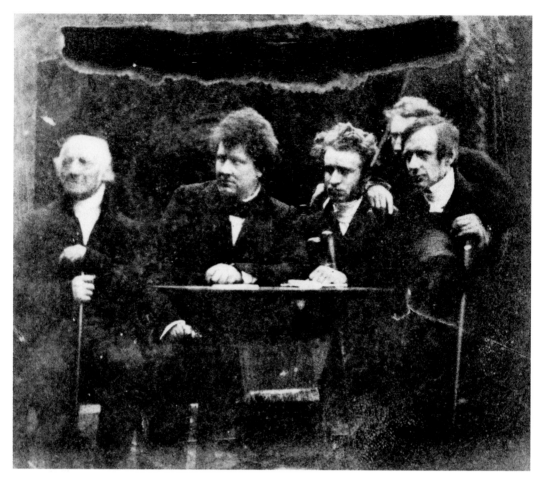

Cramond's Part in the Foundation of the Free Church of Scotland

A board within the kirk lists the post-reformation ministers from 1575. Of these, Dr George Muirhead, one of the ministers recorded on the board, led a walk-out from the church in 1843 as part of the Disruption over patronage, to found the Free Church in Davidson's Mains. He is seated on the left in this photograph and is buried in Cramond graveyard. Raeburn's 'Skating Minister', the Revd Robert Walker, also served at Cramond.

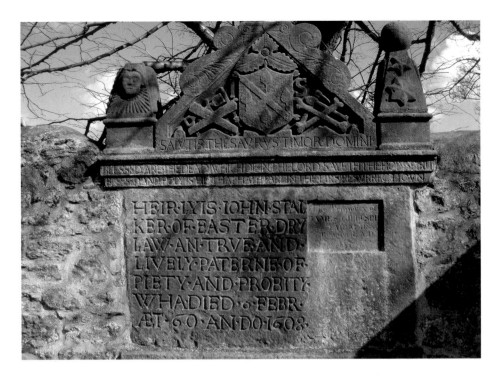

What Stories These Stones Could Tell

The oldest stone in the kirkyard, a memorial to John Stalker of East Drylaw, is dated 1608 and is on the east wall. Part of the inscription reads 'Death comes to us all without exception'. Due to the number of burials that have taken place in the kirkyard from even before records began, there is no longer any grave space available. In 1984 the kirk session created a Garden of Remembrance for the interment of cremated remains.

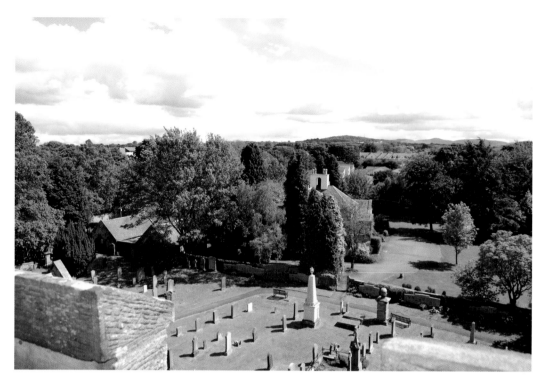

The Manse Adjacent to the Kirk
The church tower gives a bird's-eye view of the graveyard and the manse beyond, with its former stables to the rear. The manse was rebuilt in 1745 around a mid-seventeenth-century core, but later altered and extended.

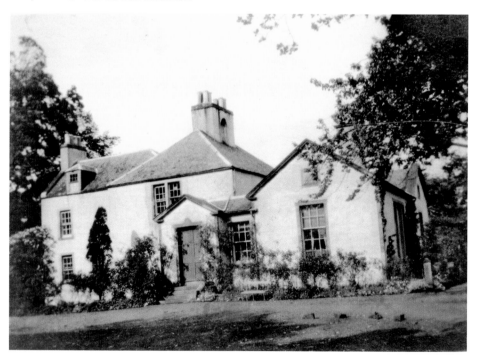

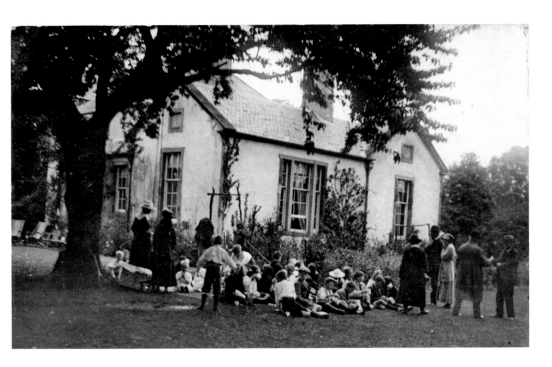

Cramond Kirk Manse

Good weather has blessed this Sunday School outing to the manse garden – the windows of the manse are open, some children are wearing hats, others have taken off their jackets, and all are tucking in to their goody bags. The photograph was taken in 1921 when the Revd G. G. Stott was minister. The haphazard rooflines of the manse and the unusual bridged chimney reveal different stages of the development of the building.

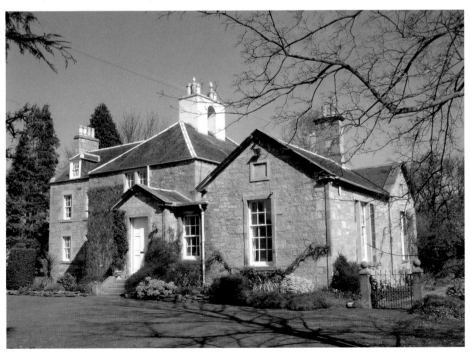

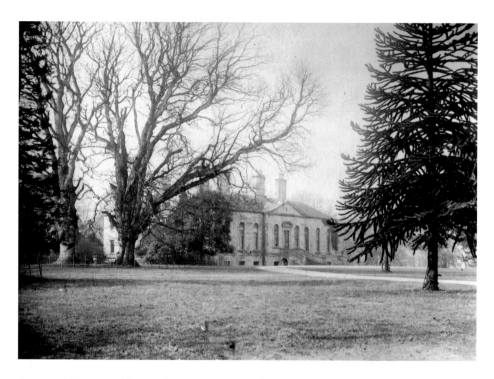

Cramond House and its Predecessor, Cramond Tower

The original Cramond House dates from around 1680. A century later it gained a new east wing looking towards the Forth, thus effectively turning its back on the village. These represented the House's best days, for it was rented by the Duchess of Kent and visited by her daughter Queen Victoria, who described it as 'quite near the sea with beautiful trees and very cheerful'. It was bought by the kirk and restored in the 1970s to preserve the amenity of the area.

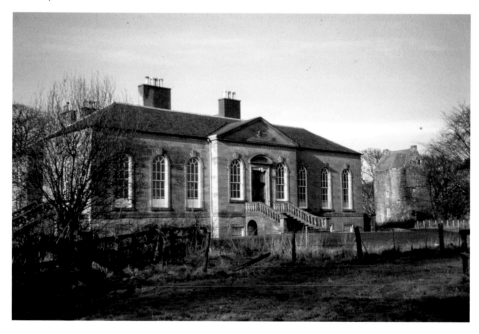

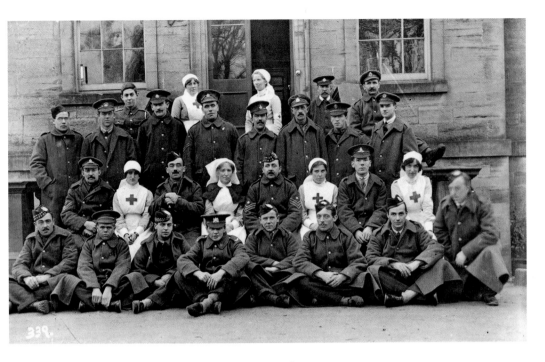

The Sombre Past and Bright Future of Cramond House

The house served as a hospital during the First World War, and the archives of Cramond Heritage Trust contain details of all the soldiers treated there. Now in the possession of the Church of Scotland, the house was leased to the National Trust and the Scottish Wildlife Trust, before beginning a new lease of life in its association with the Little Monkeys nursery in 2012.

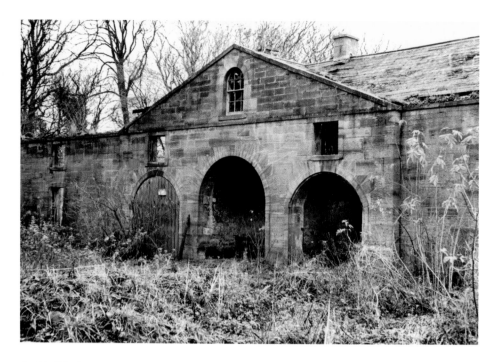

Stable Block

This magnificent stable block was demolished to make way for the kirk kalls. Ancillary buildings to Cramond House included kennels, walled gardens with sheds and a glass house, a summer house, an ice house, lodge houses and a large stable block. This last structure was demolished in 1963 to make way for a two-storey suite of church halls. Since there is no alternative provision in the area, these premises are extensively used by the community. To cater for this demand and to celebrate the millennium, the halls were considerably enlarged.

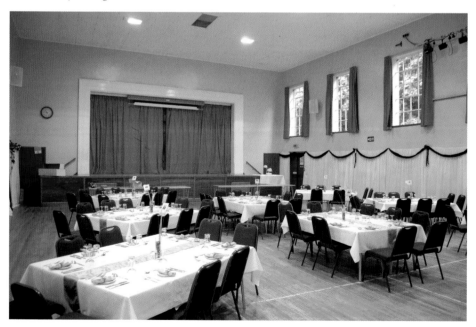

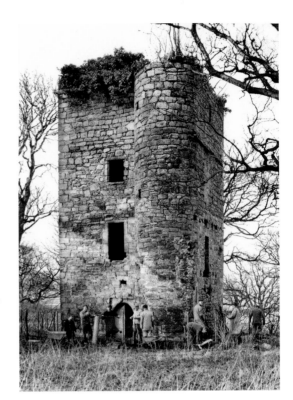

The Rehabilitation of Cramond Tower

In its heyday the tower was the summer residence of the Bishops of Dunkeld, one of whom died there in the thirteenth century. Abandoned in the seventeenth century when the owners moved to Cramond House, it was rescued by the present owner and adapted as a residential home and workshop.

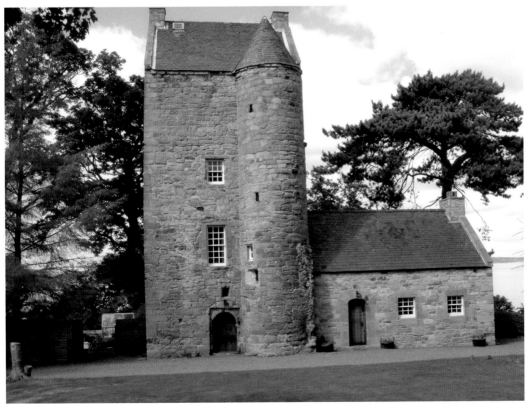

15

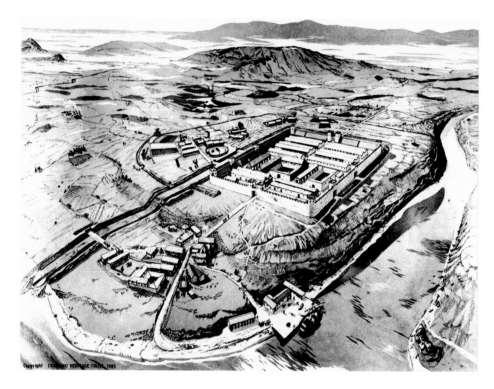

Copyright CRAMOND HERITAGE TRUST, 1985

Roman Occupation

The story of Cramond's Roman occupation is still being unearthed. Cramond served as a Roman garrison on two occasions, and the kirk is sited on the headquarters of the fort. Artefacts such as pottery, glass, coins dating from AD 79 to 205, leather footwear, jewellery, tiles and bricks are frequently found in the area. The bathhouse of the camp remains unexposed near Cramond Inn.

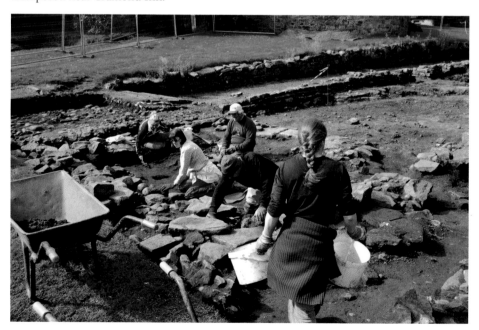

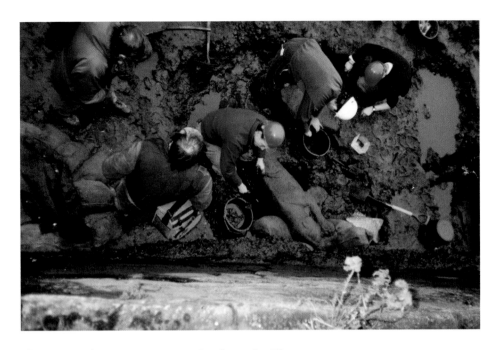

The Roman Lioness Statue Emerging from the Silt

The most sensational find reflecting the Roman occupation of Cramond in the second and third centuries was that of a sandstone lioness, which had lain in the mud adjacent to the ferry steps for about 1,800 years. The sculpture has been interpreted as being for the tomb of a Roman commander or dignitary. It was found by the ferryman, who was rewarded under Treasure Trove Law. The conserved sculpture is currently in the care of the Museum of Scotland.

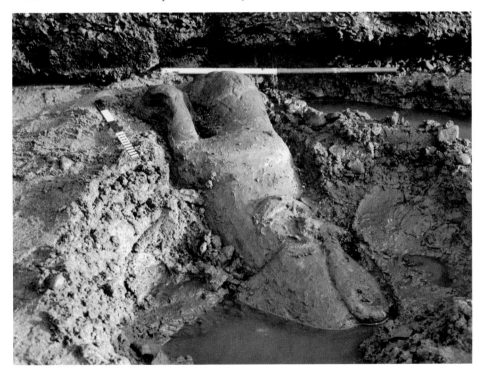

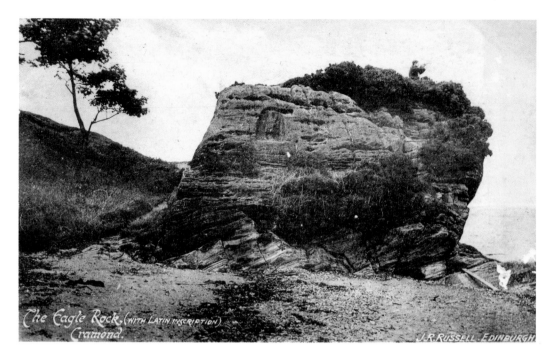

The Eagle Rock (with latin inscription) Cramond.

J.R. RUSSELL. EDINBURGH

Eagle Rock

From Cramond harbour, Eagle Rock is clearly visible on the shoreline of the Dalmeny estate. In 1794 a local historian, John Wood, described a carving on the east face of the rock of 'a sculpture bearing some resemblance to the figure of an eagle, standing upright, with its back to the rock, supposed by some to have been executed by the Romans'. While this carving is still visible, centuries of erosion mean that it is impossible to determine what it depicts.

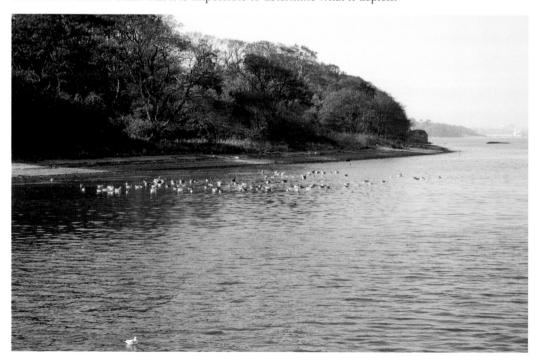

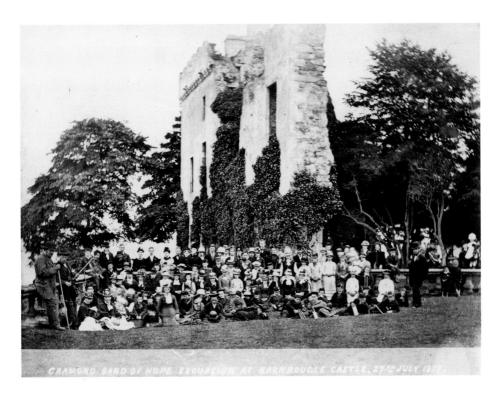

CRAMOND BAND OF HOPE EXCURSION AT BARNBOUGLE CASTLE. 27TH JULY 1879.

Barnbougle Castle

Barnbougle Castle was one of the grand residences in the former parish of Cramond by virtue of its being in Midlothian, and is still in family hands. Passed on the coastal walk from Cramond to South Queensferry, it is of thirteenth-century origin. In 1881 the 5th Earl of Rosebery, who later became Prime Minister, restored the castle to house his library. This excursion of the Band of Hope (Davidson's Mains church) took place before the restoration.

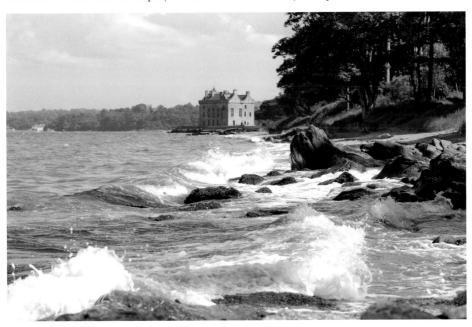

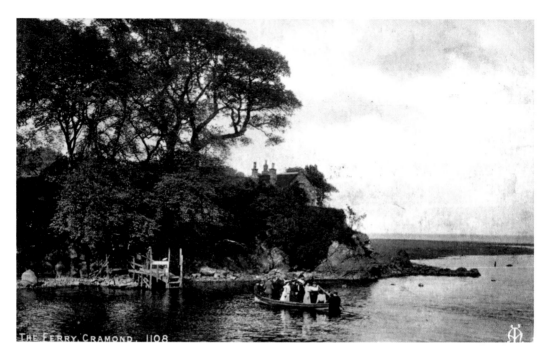

Cramond's Ferry Across the River Almond

These intrepid and well-attired navigators of the last century are voyaging on to their destination regardless of their health and safety – but landfall is in sight! If over the years until the closure of the ferry the permitted number and stance of the passengers had changed, the thrill of the crossing and the method of propulsion of the vessel remained the same. Cramond Boat Club's clubhouse overlooks the harbour.

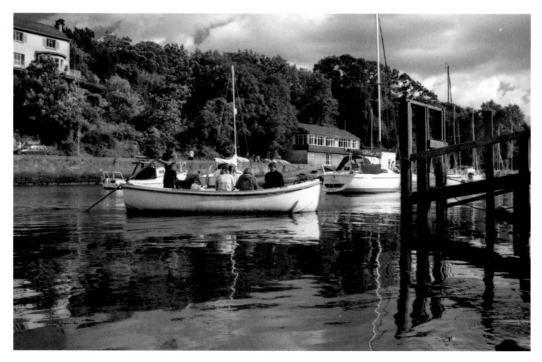

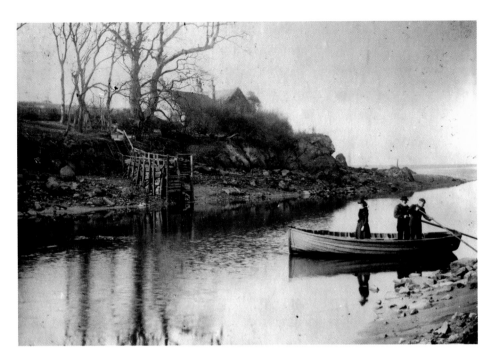

The Traditional and Proposed Replacement for Cramond's Historic Ferry

The Cramond ferry was regarded as iconic of the village and formerly gave access to a footpath along the shore of the Firth of Forth to Queensferry. An Act of Parliament in Edinburgh of 1662, during the reign of Charles II, referred to the 'coble at Cramond'. Now the traditional crossing is no more, despite the haunting presence of the ferryman's cottage beside the landing stage. However there is hope of its replacement with a new chain ferry.

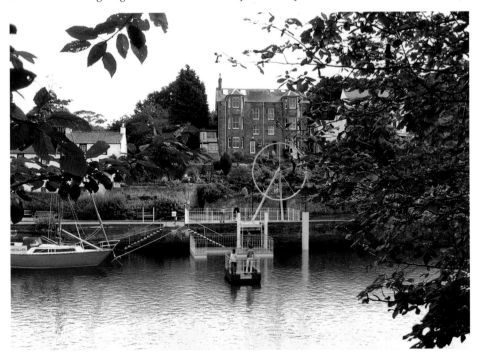

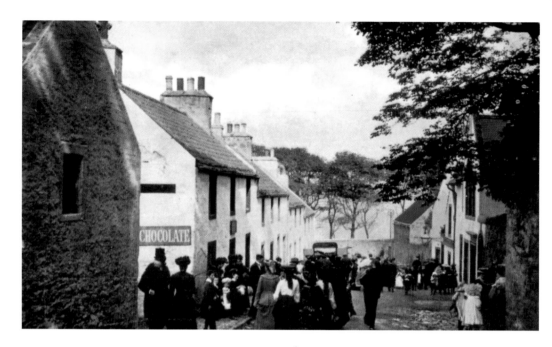

Cramond Village

The scene taking place in this quintessential 'picture postcard' view of Cramond village is a matter of local conjecture. Adults and children are in their Sunday best and are moving down to the harbour where the tide is in. Clearly there is an air of excitement. By this time Cramond Inn had its own gas plant but the rest of the village still had to make do with paraffin lamps and candles. In today's village, power from electricity is available to all.

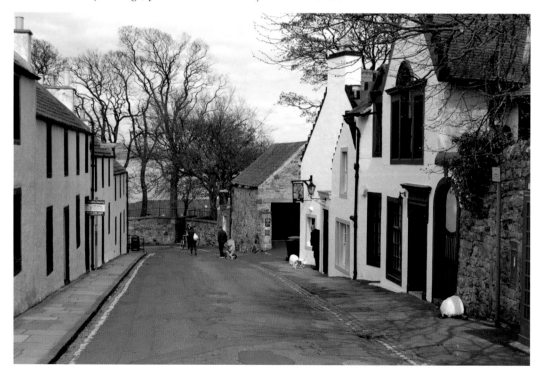

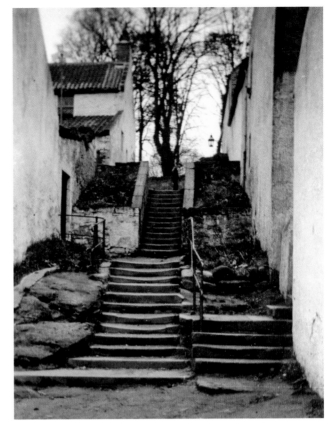

Sailor Street

Originally called Sailor Street, these steps would appear to have no maritime connection other than that they lead from the village to the harbour. Wood (1794) noted that since 1740, when eleven large boats had been employed, the oyster fishing had been at a low ebb, destroyed by overfishing and pollution. Additionally, fishing in the River Almond, which had abounded in trout, grilse, salmon and smelt, had been killed by pollution from upstream.

23

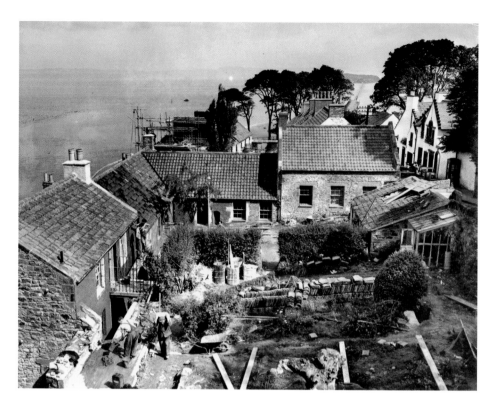

Cramond Village's Historic Dwellings Saved from Demolition

The displacement of Cramond village to its current location in the early nineteenth century was part of the designed landscape ambitions of Cramond Estate. Scheduled for demolition in the early 1960s, the village was purchased by the City of Edinburgh Council and rehabilitated. The whitewashed, pantiled housing for millworkers was saved, and the vernacular of a Scottish fishing/industrial village was retained and its character preserved.

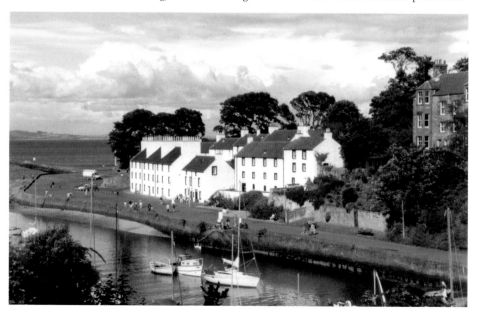

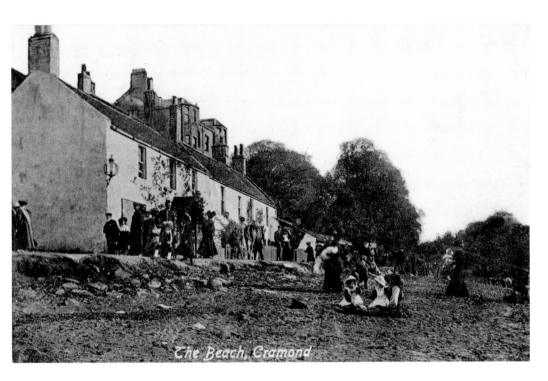

The Beach, Cramond

The Royal Oak Inn and The Maltings

The Royal Oak Inn, on the left, stood on Shore Street at the foot of the Sailor Street steps. It was a large establishment, having its own brewery, accommodation and stabling for visitors' horses. In his book *St Ives*, Robert Louis Stevenson refers to the inn as the 'University of Cramond'. The inn was demolished in the 1970s following the restoration of the village. Its Maltings, to the rear, now serves as an education and exhibition centre.

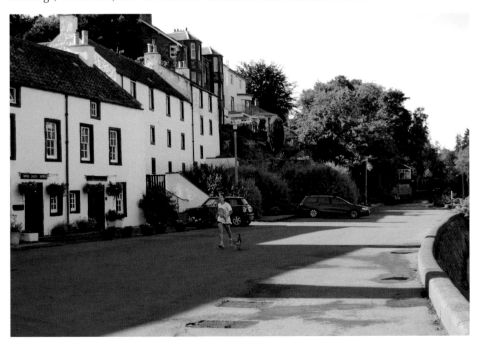

25

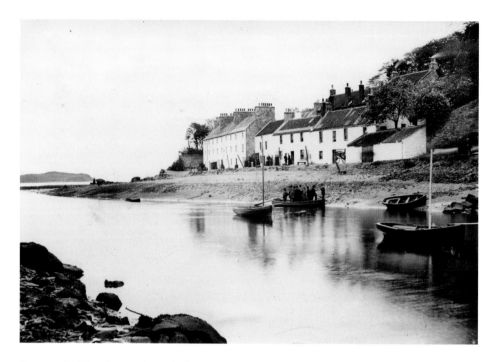

Cramond Village's Housing of Character, If Not Comfort

Cramond village was originally part of Cramond Estate. This early village scene, with a distant view of Cramond Island, tends to draw a veil over the overcrowded conditions in the village houses. Condemned as being unfit for human habitation, they were rehabilitated in the early 1960s when Edinburgh City Council purchased the estate. The original inhabitants were given the option of returning to the village. Few took up the offer, their memories of the old slum conditions being too strong.

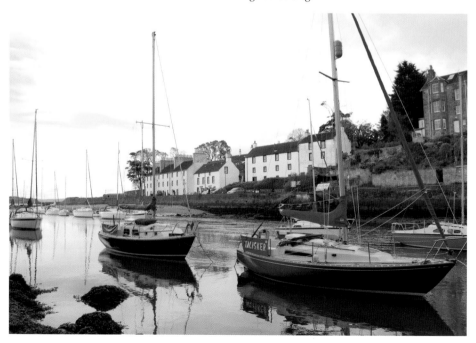

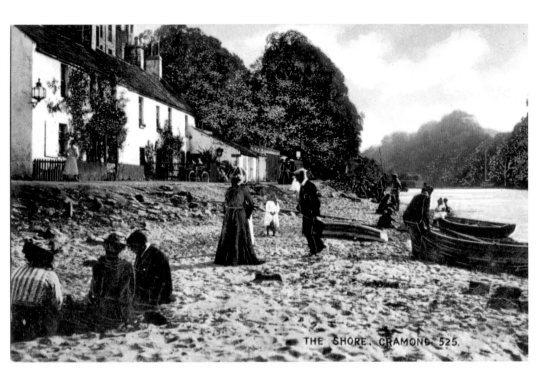

The Shore. Cramond 525.

Cramond's Former Riverside Beach

The village has been a recreational venue throughout the centuries. Robert Louis Stevenson was a regular visitor, staying with the Reverend Colvin in the manse. Beach activities have changed very little apart from the manner of dress of the participants. The young dinghy sailors practising their sailing skills would have been severely restricted in the earlier types of clothing.

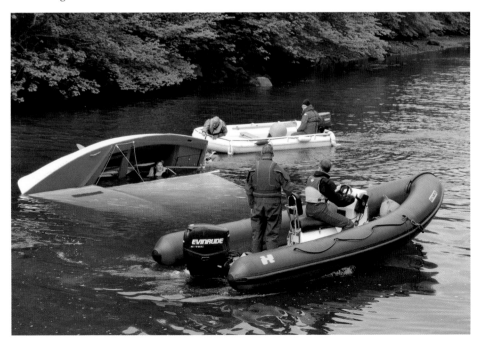

27

Henry Baillie, Cramond's Local Worthy

Henry Baillie, on the left, was the Cramond haulage contractor who also ran a carriage service between Cramond and Barnton Station. He is remembered locally for his dislike of the Cramond minister, Doctor Stott, and his refusal to convey him from the station to Cramond on one particular occasion. His carts were used to carry everything from coal and refuse to, in one case, the body of a Cramond Island resident to his final rest.

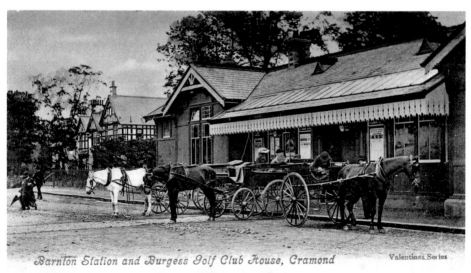

Barnton Station and Burgess Golf Club House, Cramond Valentines Series

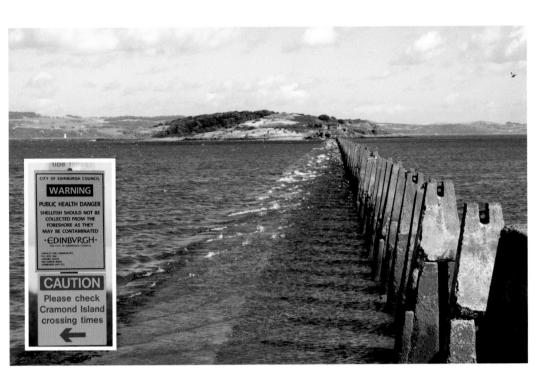

When Is an Island Not an Island?

A concrete barrier linking Cramond Island to the mainland was built at the start of the Second World War to prevent the passage of enemy surface craft. The island has served a variety of purposes: as a seventeenth-century haven for 'unfortunate females requiring temporary retirement', for the grazing of sheep and farming, for quarrying, as holiday accommodation and as a defence in both World Wars. Now its use is purely recreational – but let the visitor beware of the tide!

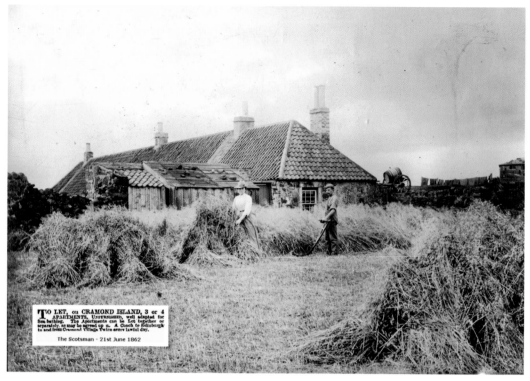

TO LET, on CRAMOND ISLAND, 3 or 4 APARTMENTS, Unfurnished, well adapted for Sea bathing. The Apartments can be Let together or separately, as may be agreed up n. A Coach to Edinburgh to and from Cramond Village Twice every lawful day.

The Scotsman - 21st June 1862

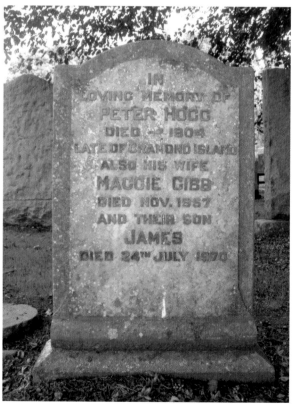

IN
LOVING MEMORY OF
PETER HOGG
DIED — 1904
LATE OF CRAMOND ISLAND
ALSO HIS WIFE
MAGGIE GIBB
DIED NOV. 1957
AND THEIR SON
JAMES
DIED 24TH JULY 1970

Cramond Island's Last Inhabitants

Peter Hogg and his wife were the last to farm on the island. Both are buried in Cramond kirkyard with their son. While the island had its own well, and supplies could be taken across to it at low tide, holiday rental accommodation on it could only be described as 'basic' by modern standards. The island belongs to Dalmeny Estate.

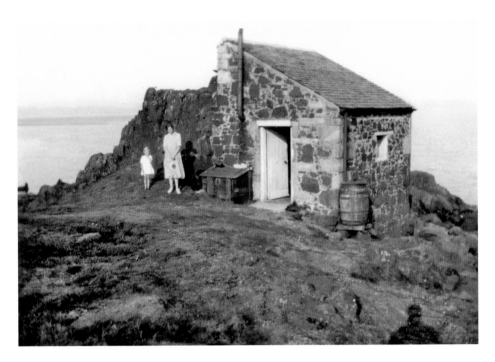

Island Buildings Used as Holiday Accommodation to Supplement the Farmer's Income
The old 'Duck House', on a promontory at the north-west tip of the island, was built as a shelter for duck-shooting parties. It was one of the apartments 'well adapted to sea bathing' that were let as holiday accommodation. Little remains of the building now, although it was still sufficient to provide temporary shelter from the Firth of Forth's driven rain for this hardy group of walkers from Corstorphine.

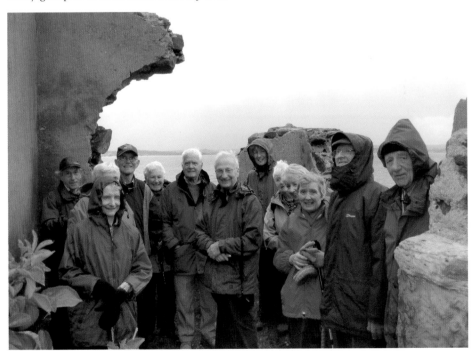

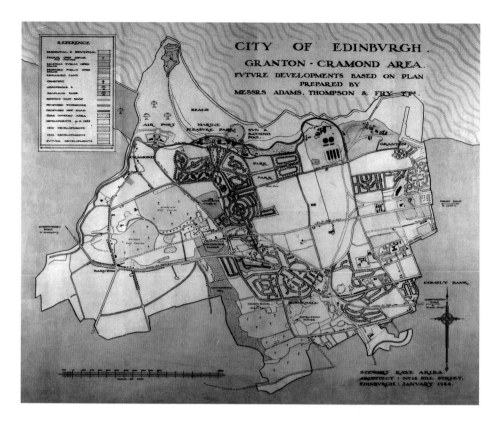

Cramond's Gain by Losing Its Proposed Airport

With the increased use of air transport, Edinburgh needed an airport capable of handling land and sea planes. The 1934 plans for north-west Edinburgh show that the sands along Silverknowes foreshore were to be reclaimed for land aircraft and the waters of the River Almond were to be impounded to form a lake for sea planes. It also shows the intended road plan. The Second World War diverted construction onto a war footing and this plan, though started, was never completed.

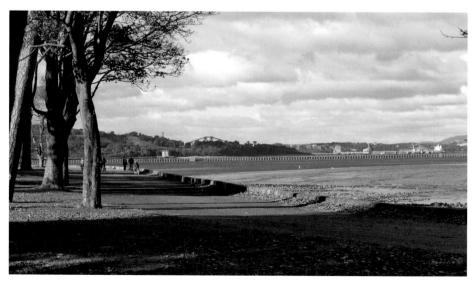

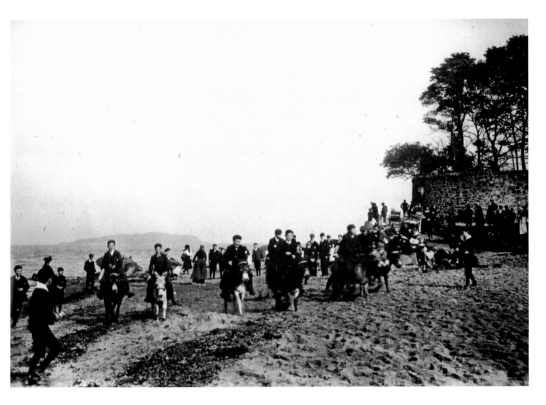

Changes to Holiday Activities on Cramond Foreshore

On a day out at Cramond, donkey rides and races were popular attractions for the trippers. Other pastimes included the hiring of a rowing boat to go up the Almond, crossing to the island, walking in the fresh air, bathing, or letting the children play on the sand. Sailing schools now adopt a more regulated approach.

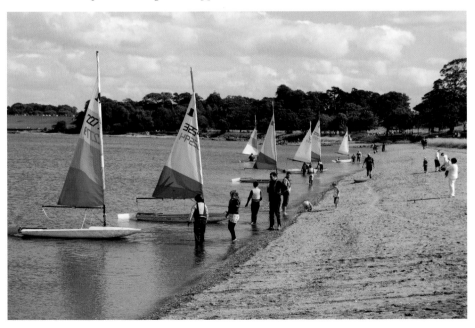

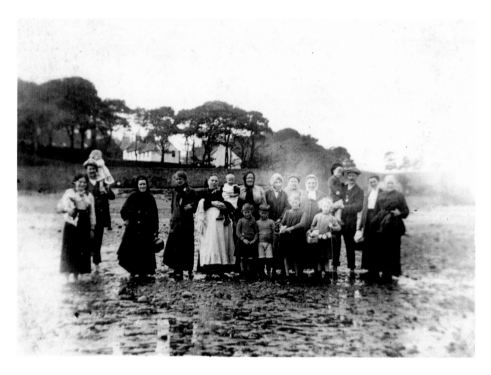

Residents of Cramond Village

For these residents of Cramond village in around 1900 life would have been hard. There was little space for a family, the rooms were dark, sanitation was primitive and the garden areas were given over to drying greens. Employment for men would mostly be land-based, while for women the choice lay between domestic service and farm work. A century earlier, their diet of oatmeal for breakfast and supper, supplemented by shellfish in winter, was said to be a healthy one.

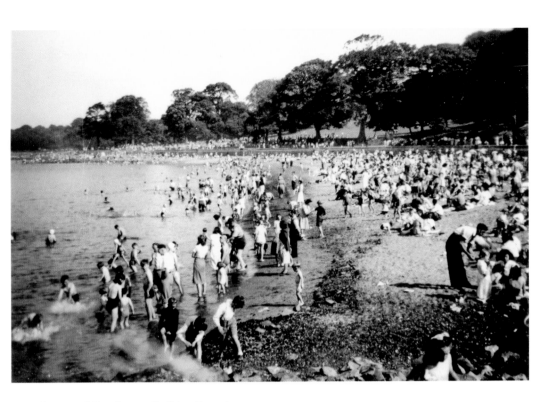

Cramond Beach as a Holiday Resort

It is 1949 and the beach, now free from wartime access restrictions, is crowded with visitors. Today the beach is still a popular venue, but with cheap foreign travel available the large crowds of early years are no more.

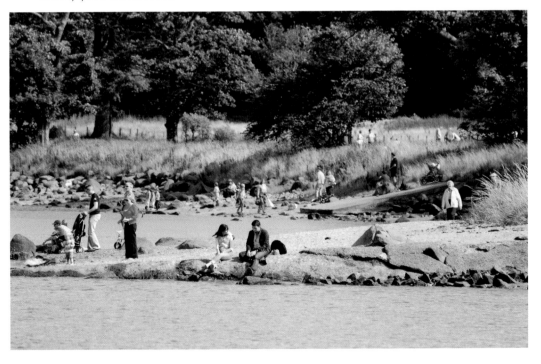

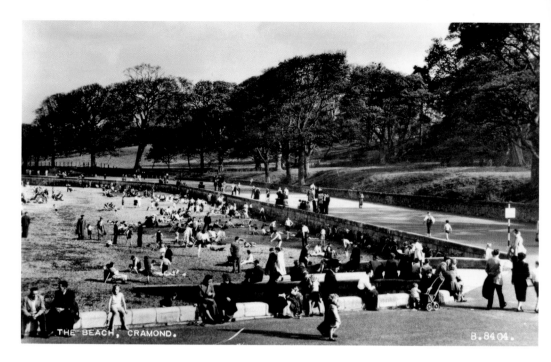

THE BEACH, CRAMOND.

B.8404.

The Promenade, Stretching from Cramond to Granton

The pace has clearly increased from the 1950s and the venue moved from the beach to the promenade. On Saturday mornings at 9.30 a.m. runners take part in what is part of a national series of events by running a 5 km return route along Cramond/ Silverknowes promenade. Registered runners receive an individual barcode and get their individual times via the web. It is free and marshalled, kilometre markers are in place and it is a wonderful spectacle. Everyone is a winner.

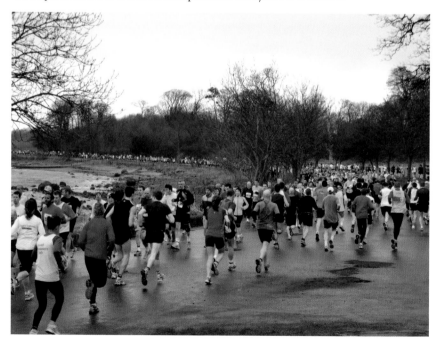

The Cramond Fish

The stooks in the fields leading down to the foreshore appear to have suffered from rough weather. The sculpture of a fish, mounted on the Cramond foreshore, is made of more robust material: 460-million-year-old Corennie granite. In 2009 the local community raised funds to purchase and install the 8-ton work of art. It was carved by Ronald Rae, a local sculptor of national and international renown, whom the community have taken to their hearts.

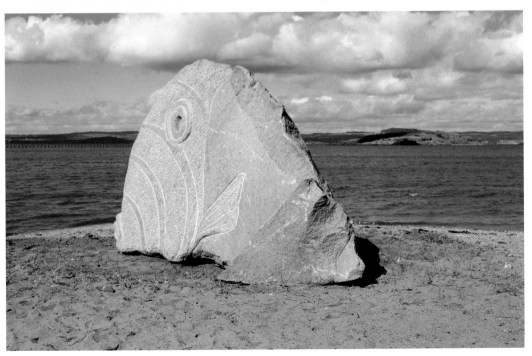

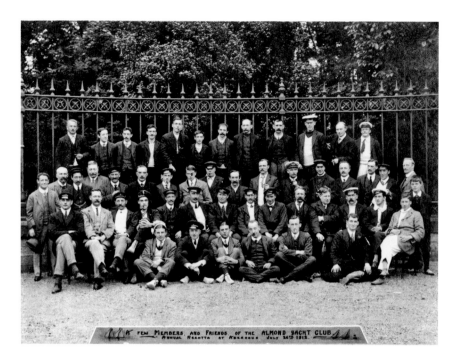

A FEW MEMBERS AND FRIENDS OF THE ALMOND YACHT CLUB ANNUAL REGATTA AT CRAMOND JULY 24TH 1912

Messing About in Boats

The Almond Yacht Club had a membership that regarded wind as the only form of power suitable for a gentleman. The increasing numbers of vessels powered by internal combustion engines operating from the river impelled them to leave the Almond and move to the central pier at Granton harbour. Cramond Boat Club was formed in 1932 with a more egalitarian attitude. Today all types of boats are used on the river by members of all ages and abilities.

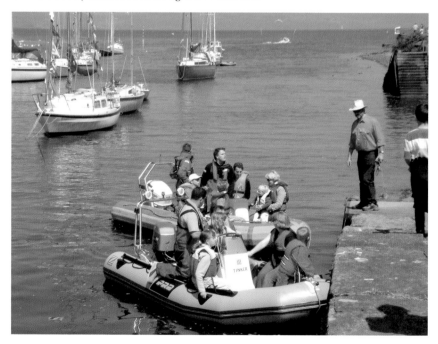

The Ups and Downs of Harbour Life

The River Almond suffers from winter spates which can carry down large logs and debris capable of interfering with the boats and their moorings. To avoid this, the boats are lifted out at the end of the sailing season and the moorings examined prior to relaunching the boats in spring. The modern crane is more sophisticated than that used to recover the fishmonger's van after its brakes failed, but they each manage to attract a crowd of interested spectators.

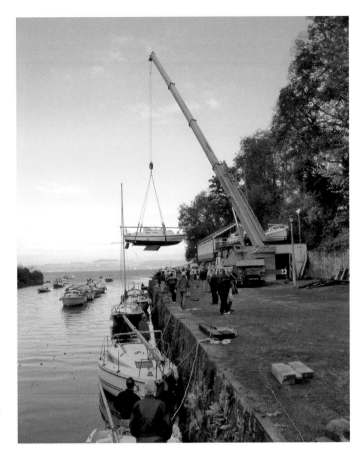

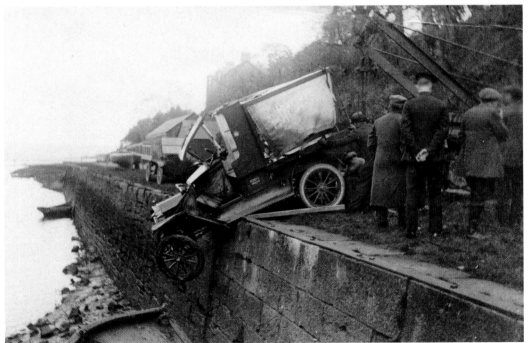

CRAMOND BOATING CLUB 246 5

Cramond Bowling Club

The bowling club was formed in the 1890s and remained active until 1932. The bowling green was then reoccupied by the Cramond Boat Club, as indicated by the title of this photograph. The green is now used as the boat club's dinghy park and for the winter storage of larger boats.

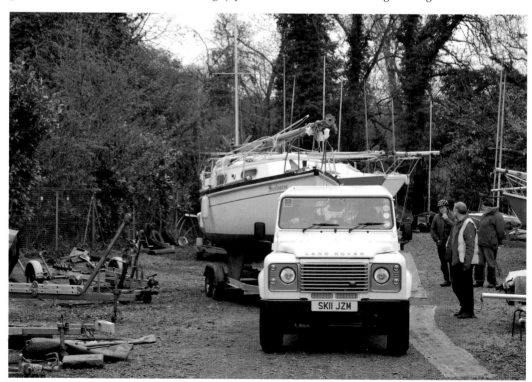

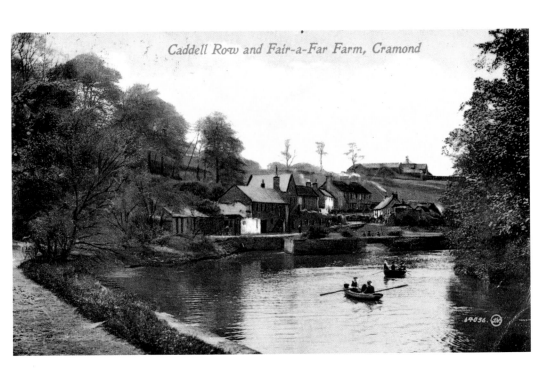

Caddell Row and Fair-a-Far Farm, Cramond

Cockle Mill

Cockle Mill was the first of the four lower mills on the River Almond to be converted for ironworking in 1752. Until 1855 all power for the mill was derived from water, but this was then superseded by steam power. Ironworking on the river stopped altogether with the closure of Cockle Mill in 1873. The mill office buildings have now been rehabilitated after lying derelict since the Second World War, one of them housing a pleasant café.

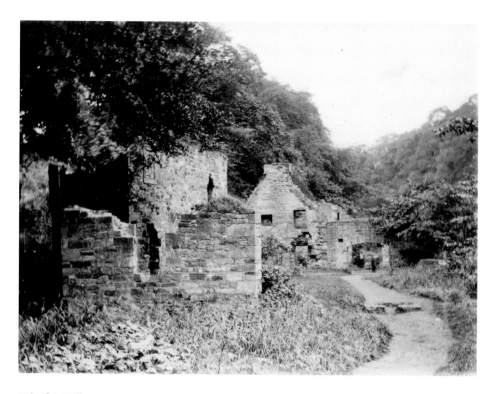

Fairafar Mill

Fairafar Mill was originally a grain and waulk mill. In 1773 it was turned into a works forge producing files, plough-socks and griddles. It had two furnaces with chimney stalks and a tilt hammer. Estate maps show a tramway or horse railway connecting it to Cockle Mill and a dock for transporting coal and iron. Ironworking ceased here in 1861 with the sale of this and Cockle Mill to Inglis of Cramond Estate.

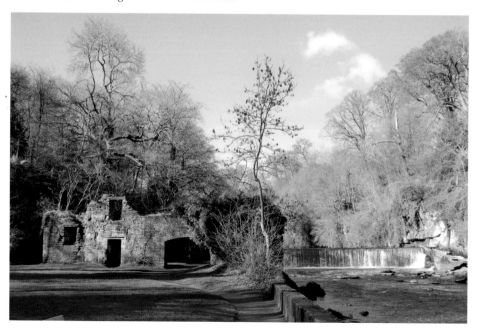

The Linking Up of the River Almond Walkway

Prior to a stairway being built there was no path linking Fairafar Mill to Peggy's Mill. Captain H. K. Salvesen of Inveralmond House intended selling his estate for building development, but generously offered a strip of land bordering the River Almond to the City of Edinburgh to enable a path to be constructed. This offer was turned down but after negotiation by the Cramond Association it was finally accepted. The path was opened on 14 May 1966 by the captain.

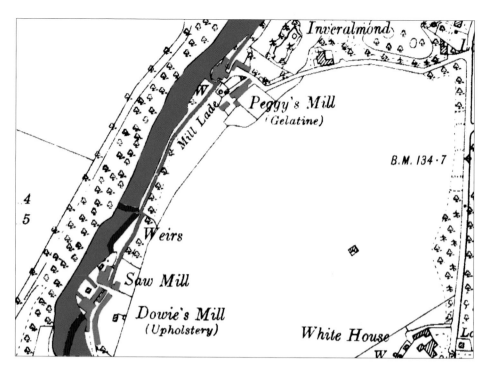

Peggy's Mill

The supply of water to power the mill's machinery was a frequent bone of contention between the proprietors of Peggy's Mill and Dowie's Mill when both were involved with furniture manufacture. In an attempt to mitigate the problem they made a dual dam arrangement, shown in the extract from the 1894 OS map, with an associated complex array of sluice gates, but to little effect. Despite being the last of the mills in operation, the demolition of Peggy's Mill in 1964 left minimal trace of its existence.

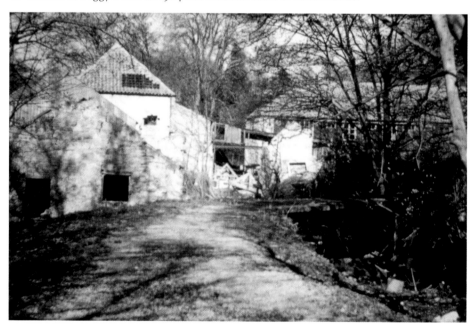

44

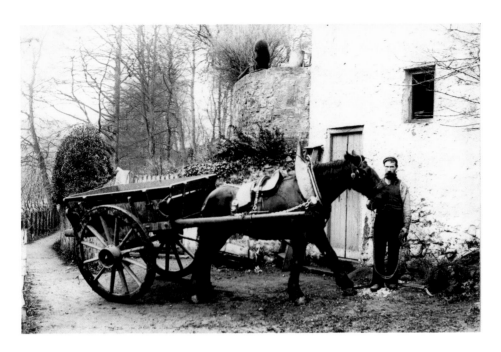

The Manager's House at Dowie's Mill

Primrose Cottage was the Dowie's Mill manager's house. The external appearance of the house has altered little since this carter posed for his photograph outside it. The later view shows a more modern form of transport and the doorway in the curved wall of the house has been converted into a window.

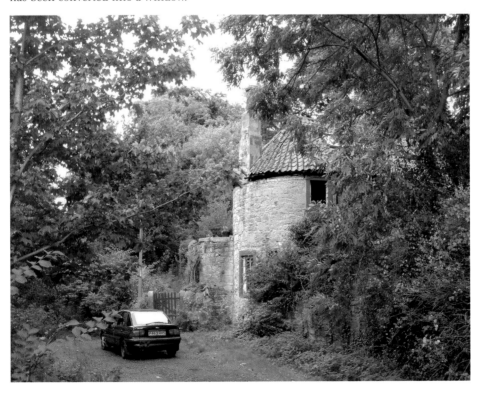

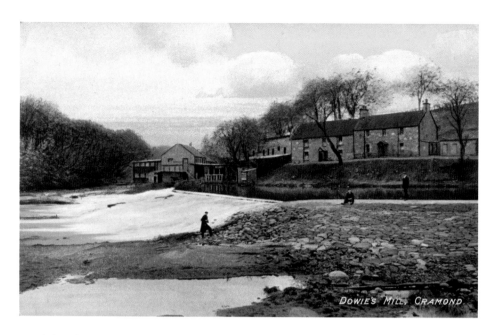

Dowie's Mill, Cramond.

Dowie's Mill

Below the Auld Brig and powered by a weir, mill lade and sluices, Dowie's Mill was referred to in a charter of 1697. In the eighteenth and nineteenth centuries it was part of an important industrial centre associated with the Caddell family. Originally a grain mill, as a foundry and sawmill it produced the shafts and heads for spades and nails, and latterly turned to upholstery. The waterfall drop was 2.4 metres and there were two waterwheels. Tied houses for the workers overlooked their workplace.

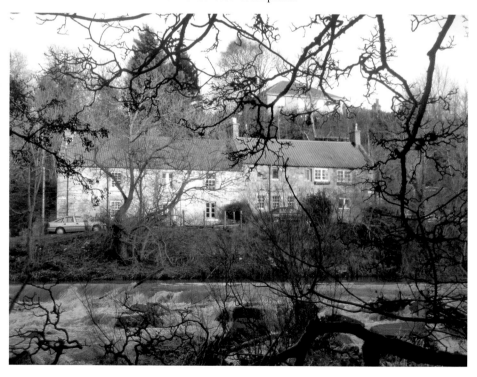

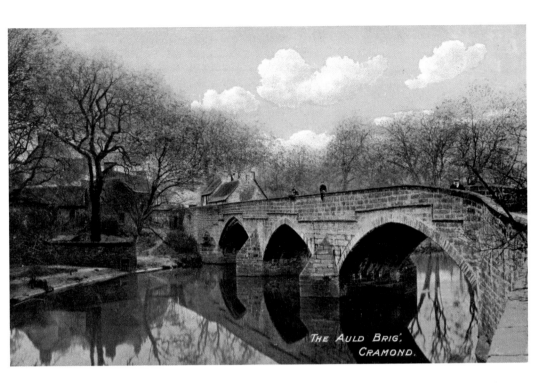

THE AULD BRIG,
CRAMOND.

Cramond's Auld Brig

A mile upstream from the harbour the historic Auld Brig crosses the River Almond. It was built around 1500 and comprises three arches supporting a narrow carriageway. Details of the repairs to the bridge, jointly shared by the shires of Edinburgh and Linlithgow, are carved beneath the western parapet. Sir Walter Scott gave immortality to the bridge in his tale of the disguised King James V being attacked there by brigands and rescued by Jock Howieson.

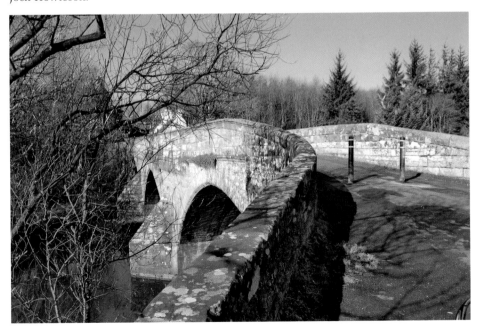

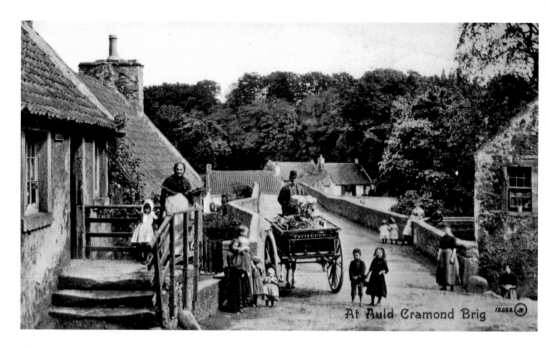

At Auld Cramond Brig

The Community at Cramond Brig

There were more houses at Cramond Brig than is evident today. The life and sense of community at the bridge, which carried the turnpike road from Edinburgh to Queensferry, are shown by the number of people congregated in this picture. The cottage on the left was a greengrocer's serving the local population. The donkey cart was used to sell their produce throughout the district. The bridge closed to vehicular traffic in 1964 and is now a footbridge.

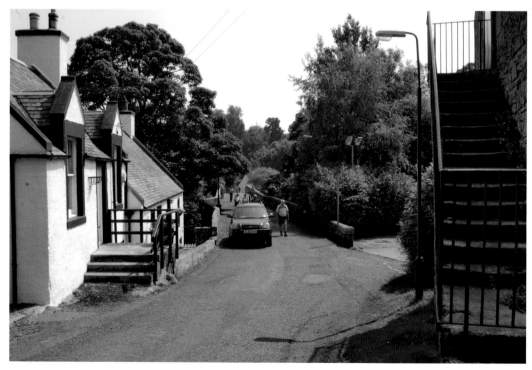

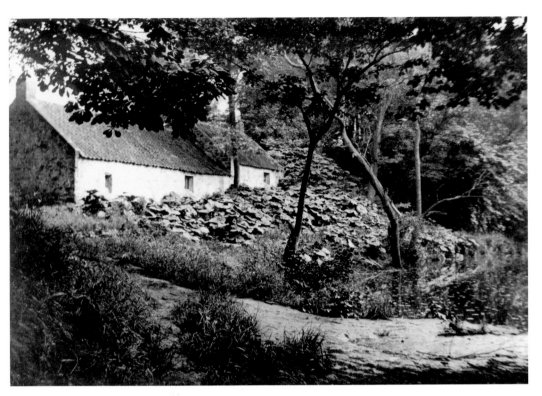

The Legend of Jock Howieson

The supposed cottage of the legendary
Jock Howieson once stood on the southern
bank of the River Almond, in the shadow
of the Auld Brig. In a courtyard of the
nearby former Braehead Farm, a fine
sculpture by Robert Forrest (1789–1852)
recalls the legend. The original 23-
ton block of stone was hauled from
Craigleith quarry by eight horses and
sixty quarrymen. Its passage along Princes
Street to Forrest's studio on Calton Hill
attracted a great deal of attention.

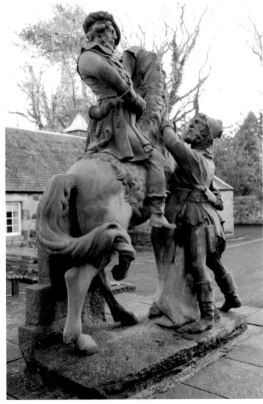

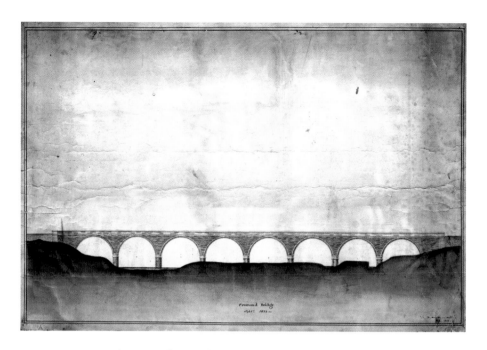

Improvements to the Turnpike Road to Edinburgh

In 1809 new piers were constructed in Queensferry to improve the ferry landing. This spurred the need to improve the road which linked it to Edinburgh, part of which included the crossing of the River Almond. A stone bridge was proposed by John Rennie (1761–1821), while a competing steel design was submitted by Robert Stevenson. This contemporary print, which was owned by Abram Rutherford, the bridge contractor, indicates which design won. The bridge was completed in September 1823.

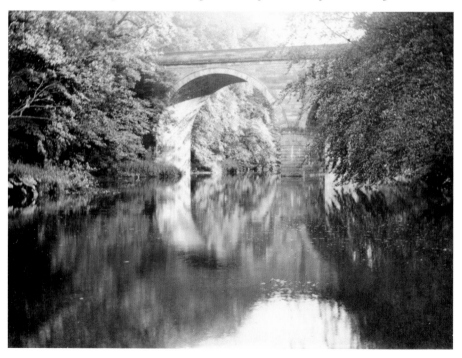

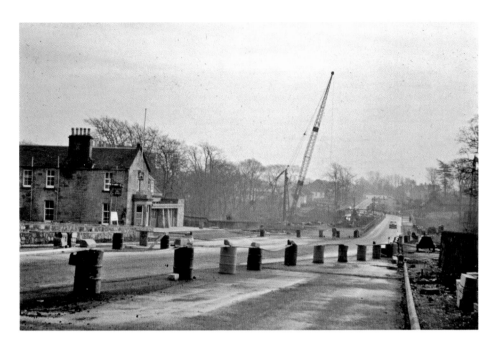

Today's River Almond Crossing

Traffic was halted in 1962 for only twenty minutes as Rennie's bridge was blown up to make way for yet another, more modern structure. Vehicles then continued their flow to and from Edinburgh towards Queensferry. Two years later the plan was completed when Queen Elizabeth opened the Forth Road Bridge. Later, due to greater, unforeseen axle weights for heavy lorries, the bridge had to be reinforced by the addition of heavy steelwork beneath the carriageway.

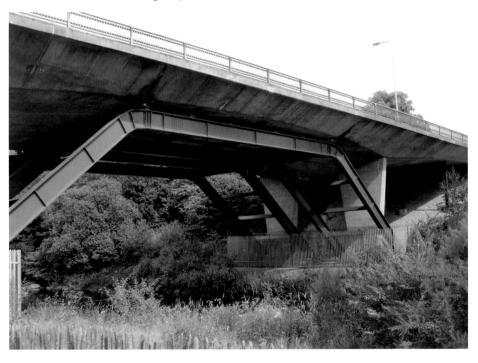

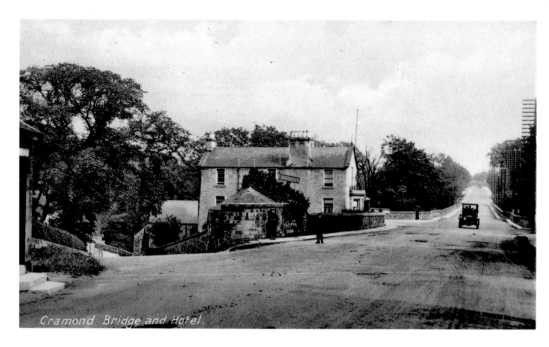

Cramond Bridge and Hotel.

Cramond Brig Hotel

The Cramond Brig Hotel stands as a welcome refreshment stop at the junction of the old road from Cramond Brig and the main road to Queensferry. Despite the old road having closed to vehicular traffic the hotel still retains its original purpose and welcomes both north and southbound drivers.

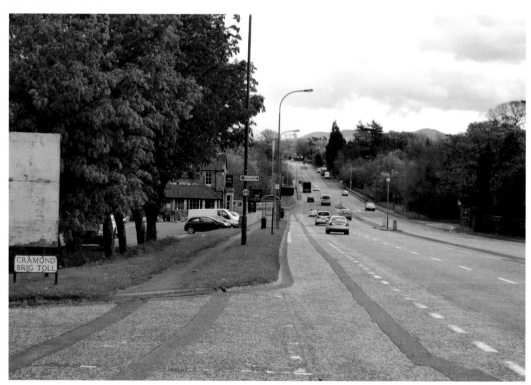

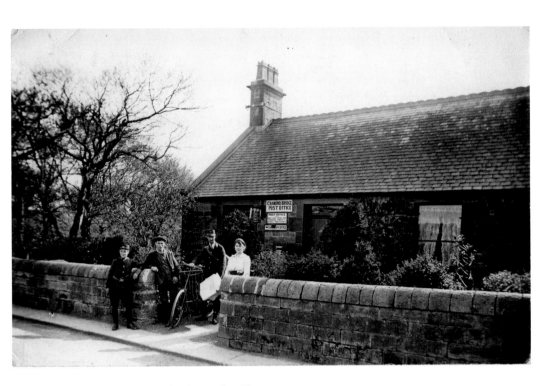

Cramond Brig's Post and Telegraph Office

Insurance, annuities, banking, letter and parcel post were conducted by the post office, situated near Rennie's bridge, but its real status came with its function as a telegraph office. The postman and telegram boy shown had a wide area to serve. The proprietors also published many of the local postcards which feature in this book. The building and Rennie's Bridge were demolished to make way for the new Cramond Bridge. The nearest post office is now in Barnton.

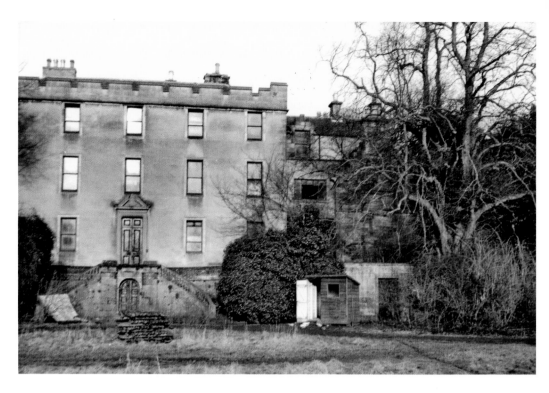

Cammo Estate

Cammo Estate belonged at one time to Sir John Clerk of Penicuik who professed 'my salary as Baron of the Exchequer was publick money ... I owed to my country ... and therefor I laid out the whole of it [Cammo Estate] for the Improvement of my Country.' Unfortunately the last owner, Percival Maitland-Tennant, allowed the estate to revert to wilderness prior to the National Trust for Scotland acquiring it. It is now run as one of Edinburgh's parklands.

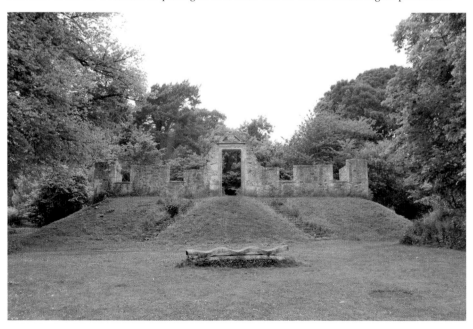

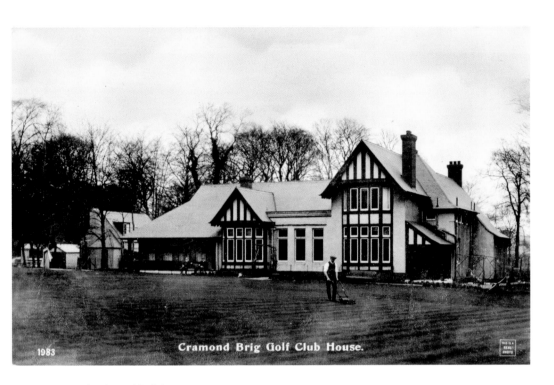

Cramond Brig Golf Club House.

Cramond Brig Golf Club

In 1908, Mrs Maitland-Tennant of Cammo House granted a twenty-one-year lease on 54 acres of land to allow the construction of a golf course, with the proviso that the clubhouse cost at least £1,000 and that Sunday play would be reserved for her family and friends. It was opened on 17 July 1909 and by the mid-1920s the membership comprised 500 males and 200 females. The club moved to Dalmahoy on expiry of their lease.

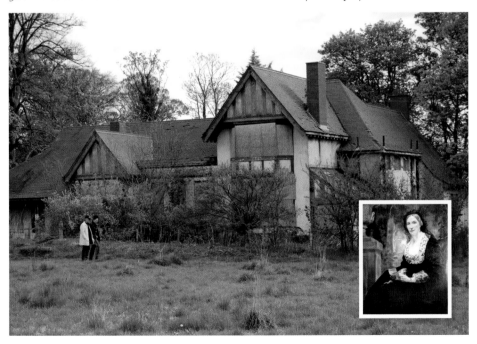

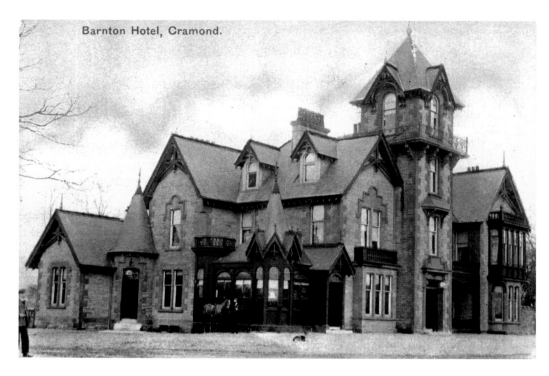

Barnton Hotel, Cramond.

The Barnton Hotel

The Barnton Hotel was opened for business in 1895, soon after the completion of the nearby Barnton Station railway terminus. The hotel was convenient for golfers visiting the nearby Royal Burgess Golfing Society. Its fifty bedrooms and five meeting rooms, the largest seating 150 delegates, also made it an ideal venue for business and holiday visitors to the area. Since its closure as a hotel in 2000 the site has been the subject of many planning applications and much controversy.

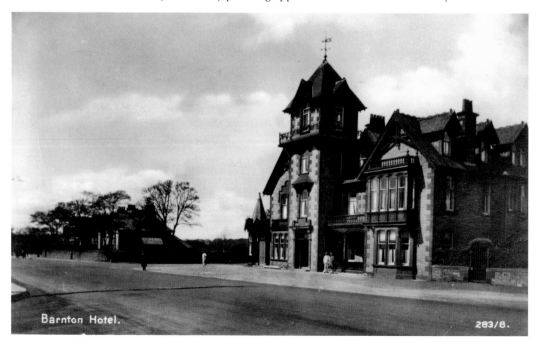

Barnton Hotel. 283/8.

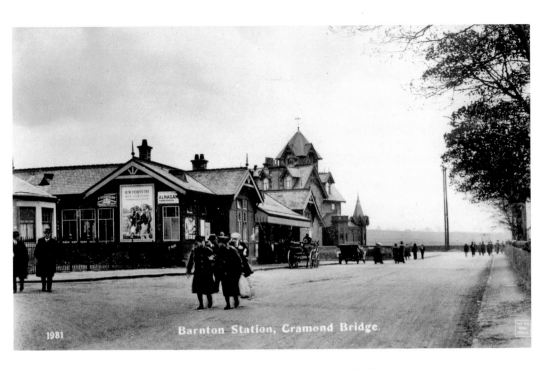

Barnton Station, Cramond Bridge.

Barnton Station, the Terminus of the Spur Line from Craigleith

Were the servicemen alighting from the Barnton Express home on leave, or arriving for duty at one of the garrisons defending the Firth of Forth during the First World War? What happened to Amalgam motor tyres? The business of R. W. Forsyth, 'men in the making', closed in the 1980s. The Barnton Hotel is now for sale while modern traffic means that a leisurely walk across the road is inadvisable.

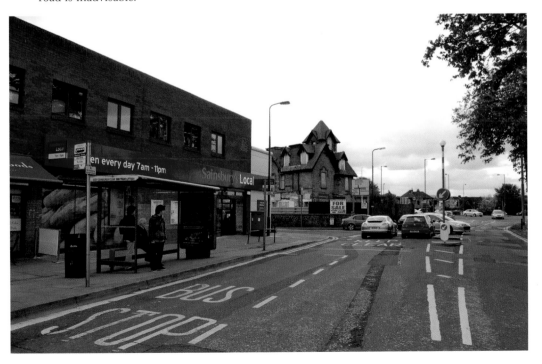

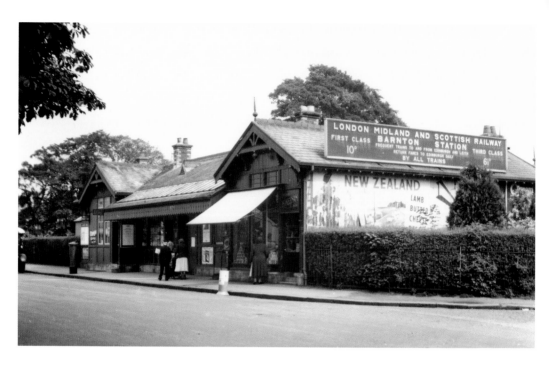

Barnton Station, Now Part of London Midland Scottish Railway

The original Caledonian Railway Company has apparently been taken over by London Midland Scottish, but a poster indicates that it has now been nationalised. Change apart, return fares to Edinburgh, at the time, were 10*d* first class, while third class was only 6½*d*. Keenan's has been replaced by the omnipresent Sainsbury's and other shops have been built on the site of the old station buildings.

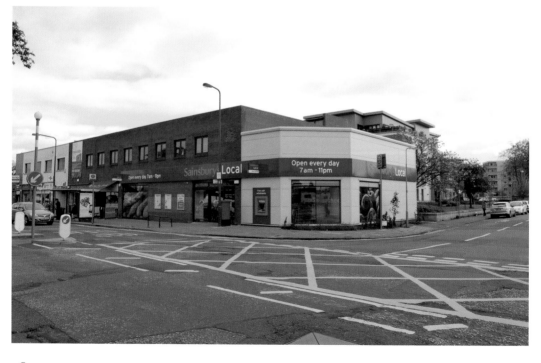

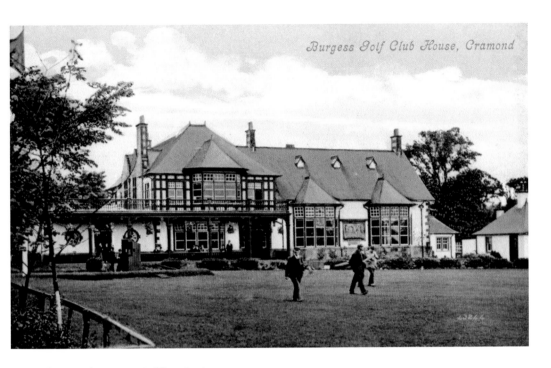

Burgess Golf Club House, Cramond

The Royal Burgess Golfing Society

The world's oldest golfing society, the Royal Burgess first began at Bruntsfield Links in 1735 but moved to Musselburgh in 1874 due to overcrowding caused by the increased popularity of the game. It then moved to Barnton in 1894. The proximity of Cramond Brig railway station (renamed Barnton in 1903) and the Barnton Hotel combined to make a very attractive golfing package at the beginning of the twentieth century.

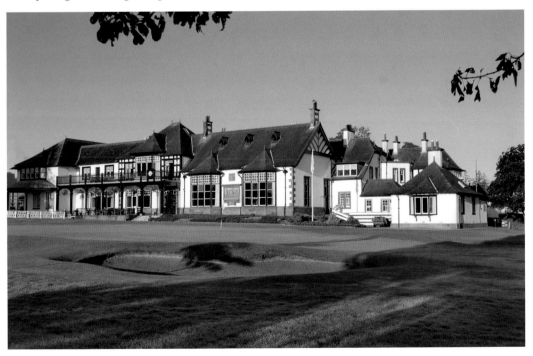

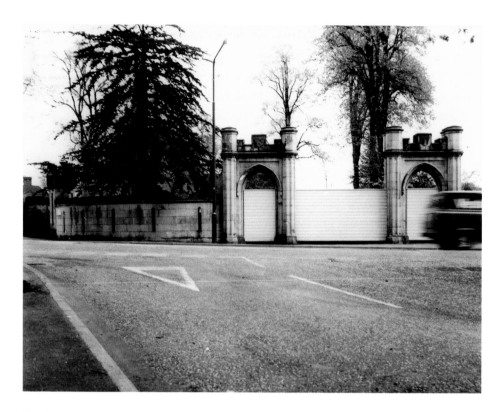

Barnton House

Behind the gates of the former Barnton House lie the links of the world's third and fourth oldest golf clubs in the former parkland estate. They were part of the ambitious plan of Sir James Gibson-Maitland of Barnton, Sauchie and Bannockburn, 6th of Barnton, 4th Baronet, to convert the pastureland of his estate into the more profitable use of property development. The house was demolished in 1926.

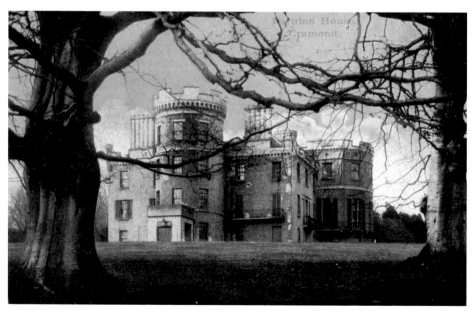

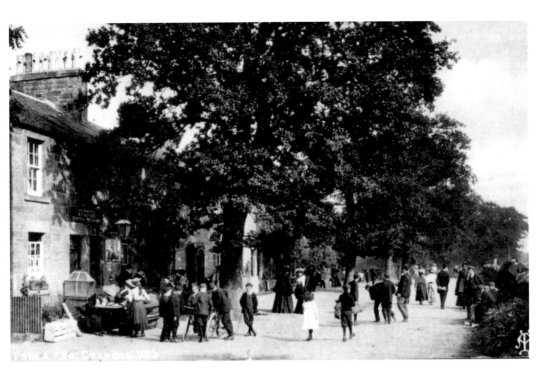

Life at Fairafar Cottages

Fairafar Cottages originally housed workers for the iron mills on the River Almond, but the mills were closed long before the people congregated to use the village shop and exchange gossip. The shop was also one of the many venues for the post office over the years. There doesn't appear to be a separate pavement in front of the houses, since the roadway extends right up to them. Two of the oak trees have managed to survive today's traffic.

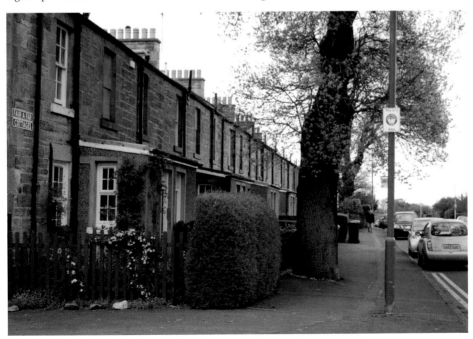

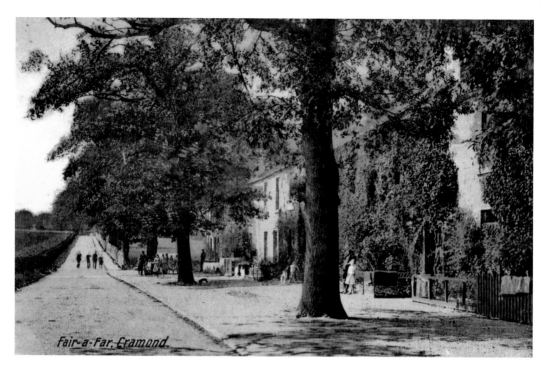

The Road from Barnton to Cramond, Passing Fairafar Cottages

Wide pavements have now been installed, leaving a narrow roadway and plenty of room for folk to socialise. The road widening necessary for modern traffic and the additional front gardens have now left a narrow pavement. The fields opposite contain a healthy crop, while those of Fairafar Farm start immediately after the cottages and were to remain until the early 1970s.

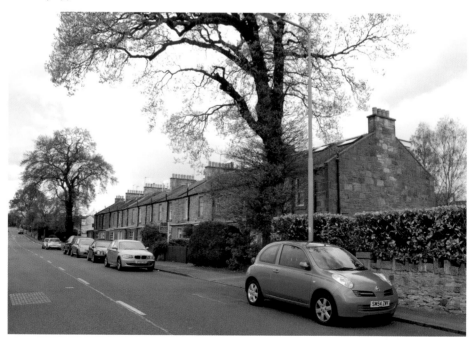

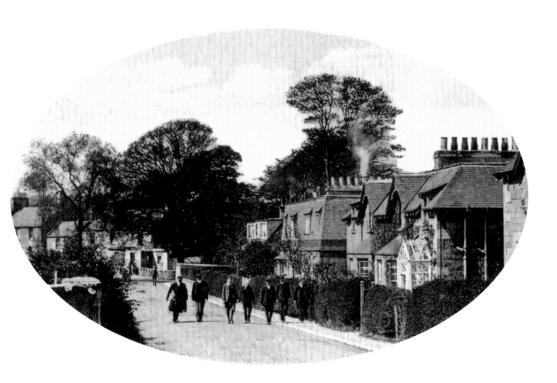

Edwardian Gentlemen and Edwardian Housing

Early in the twentieth century, the absence of fast traffic enabled this group to take a safe stroll down the middle of the narrow road. Anyone attempting to do so today would be taking a considerable risk. The road has been widened to cope with the demands of modern traffic. A lot of this is local, from the houses that have been built on what was agricultural land, although some of it is commuter traffic between Edinburgh and its hinterland.

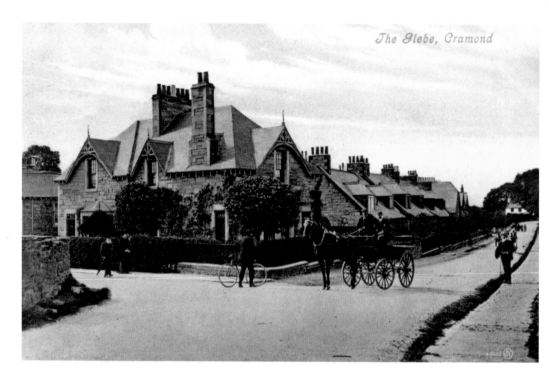

The Glebe, Cramond

The Glebe

The Glebe was a portion of land assigned for the use of the kirk's minister, enabling him to keep a horse, which he needed to travel the widespread parish, to grow vegetables and to sustain his family. Over the years this land has gradually been sold by the kirk for housebuilding. The narrow country road facing these houses has been replaced with a wide sweeping bend capable of coping with modern traffic.

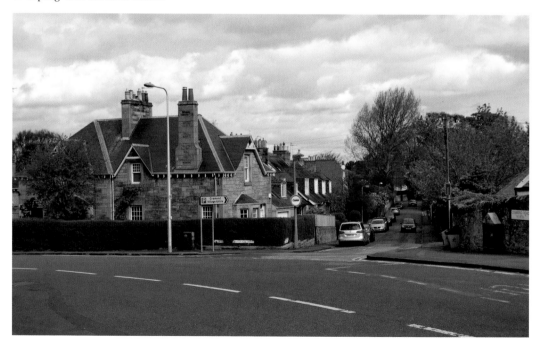

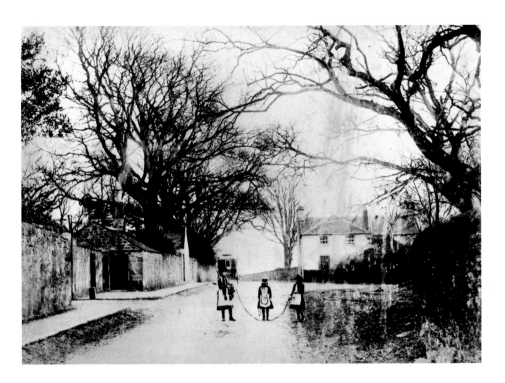

The Old Schoolhouse in Glebe Road

The Schoolhouse was built in 1778 in an 'airy and commodious place' with 'room for children to play', replacing an earlier building which stood near Cramond House. By 1794 it catered for between seventy and eighty pupils in two schoolrooms on the ground floor. It continued in use until 1875 when a new school was opened at Almondbank. The view from Cramond Kirk tower, over the schoolhouse, shows that the airy and commodious situation has shrunk over recent years.

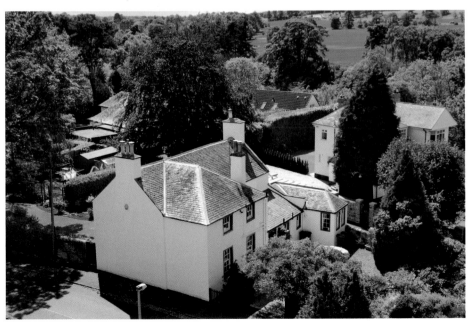

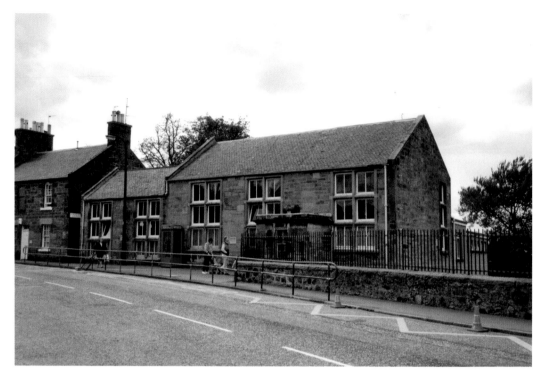

The School Which Gave Its Name to 'School Brae'

The school at Almondbank took in its first pupils on 5 April 1875 and continued in use into the 1970s. Towards the end of its school life it became heavily overcrowded due to the post-Second World War population expansion. Emergency accommodation was needed. For a few years, until a new school was built, Cramond Kirk halls were used as temporary housing for a number of classes. The old school building is now a privately run nursery.

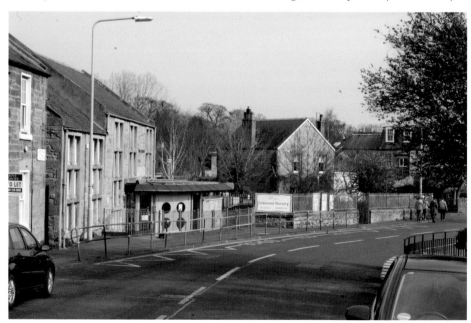

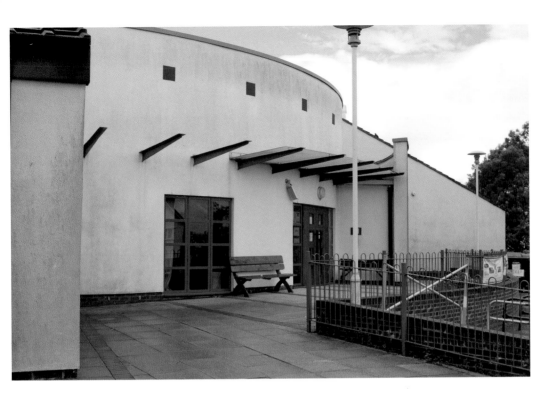

Cramond Primary School

Cramond's latest primary school caters for about 400 children from a very wide catchment area and has been extended since it was first built in the early 1970s. Like the Old Schoolhouse it is sited in 'an airy and commodious situation', being surrounded by its own playground and playing fields.

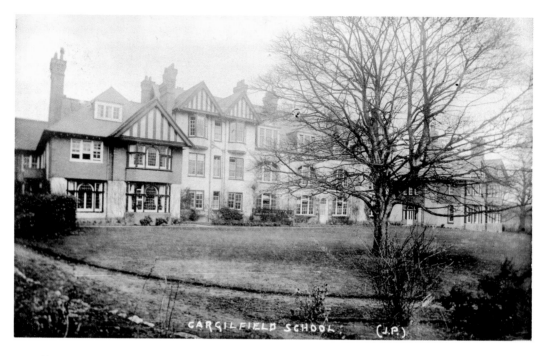

Cargilfield Preparatory School, Gamekeeper's Road, Cramond
Cargilfield, the first preparatory school in Scotland, was founded in the Trinity area of Edinburgh in 1873 by the Revd Daniel Charles Darnell. In 1899 it relocated to Cramond and lies between the Bruntsfield and Burgess golf courses. Originally for boys, it is now a private co-educational day and boarding school for children aged three to thirteen years

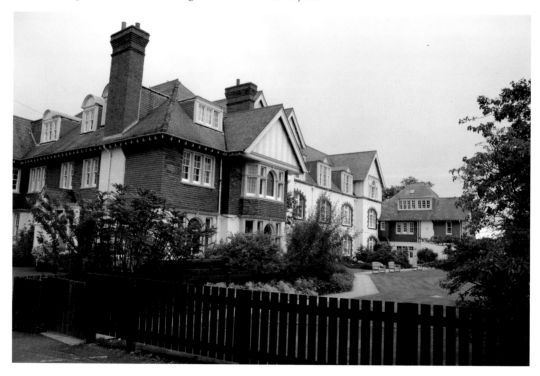

'Dumf'

Dunfermline College of Physical Education was founded by the Andrew Carnegie Trust in Dunfermline in 1905 as a training college for female students of physical education. The college had been located in Dunfermline and Aberdeen before transferring to Cramond in 1965. From 1986 men as well as women trained at 'Dumf', which was incorporated into Moray House Institute of Education a year later. It is now part of the Faculty of Education at Edinburgh University.

Cramond Road South in its Rural Setting

This vista opens up when travelling to Davidson's Mains via Cramond Road South. It encompasses the islands in the Firth of Forth and extends from Berwick Law, in the east, to Dalgety Bay and the Lomond Hills to the north-west. Agricultural land on the east of the road runs down to the Firth of Forth, while to its west is Bruntsfield Links Golfing Society. The boundary wall still shows the remains of the old Barnton House East Lodge.

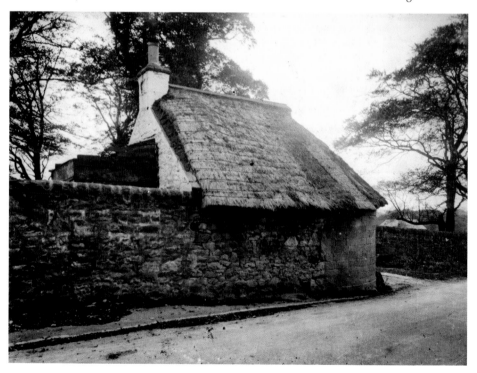

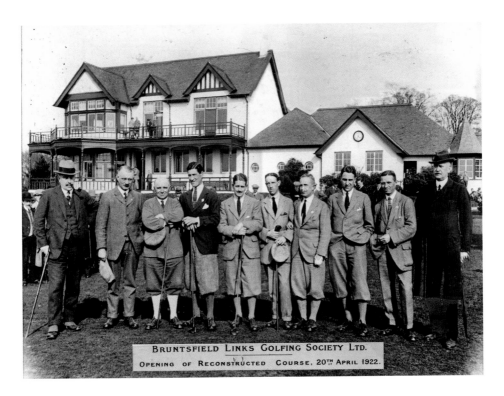

BRUNTSFIELD LINKS GOLFING SOCIETY LTD.
OPENING OF RECONSTRUCTED COURSE, 20TH APRIL 1922.

The Bruntsfield Links Golfing Society

Davidson's Mains represented the first experience of Bruntsfield Links Golfing Society owning a course of its own. The extension of the railway line from Craigleith Station to Cramond Brig Station (Barnton) stopping at Barntongate Station (Davidson's Mains) was a crucial factor in its move from Musselburgh in 1898. In 1922 Dr Alexander MacKenzie redesigned the course, originally planned by Willie Park. In recognition of its 250th anniversary, the R&A awarded BLGS Open Regional Qualifying Status from 2011.

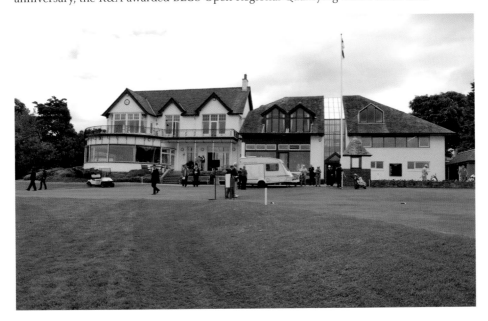

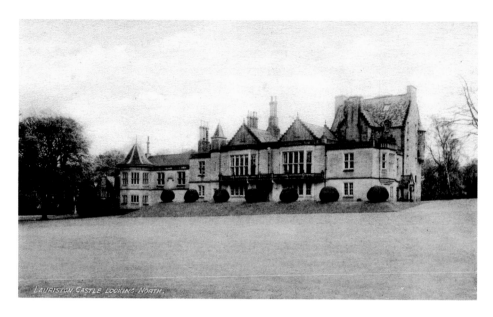

LAURISTON CASTLE LOOKING NORTH.

Lauriston Castle and Its Contents Were Left to the Nation in 1926

The castle was built for the Napier family around 1593. The last private owners, Mr and Mrs W. R. Reid, who owned one of Edinburgh's leading cabinetmaking business, decorated and furnished the castle to a high standard before leaving it and its contents to the nation in 1926. The 30 acres of the castle have a magnificent view across the Firth of Forth and were laid out by William Playfair in the 1840s. Croquet (what else?) is still played on the lawn.

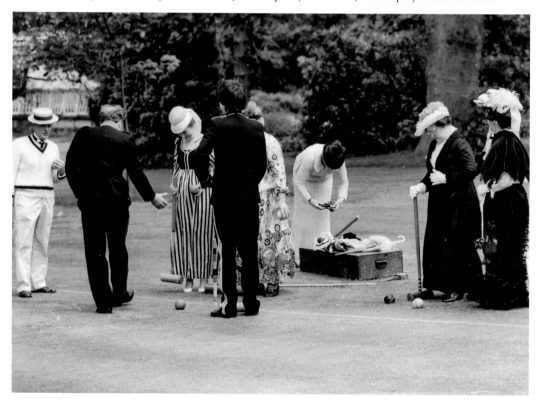

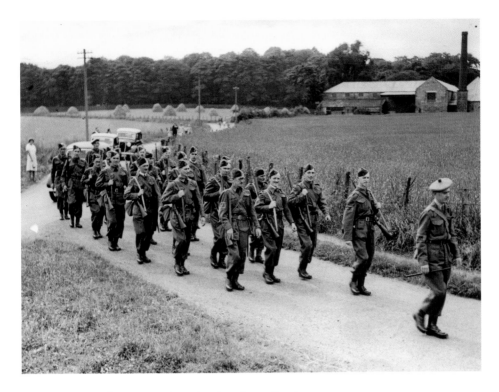

The Home Guard Company Based at Lauriston Castle

'A' Company, 1st City of Edinburgh Battalion, Home Guard, was based at Lauriston Castle during the Second World War. The gun ports cut into walls around the village are evidence of their activities in the area. Those shown are in the north of the castle's perimeter wall. The magnificent view through them was, to the Home Guard, a wide field of fire. While they were never called on to put their skills into practice, they were not the figure of fun conjured up by *Dad's Army*.

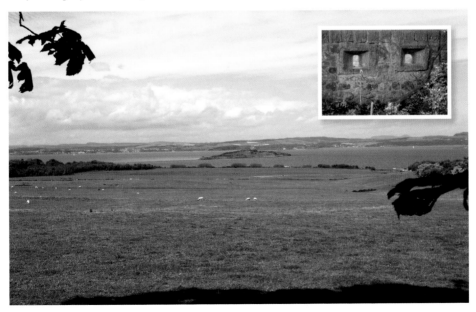

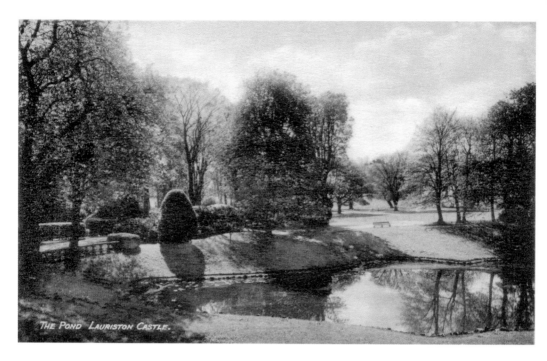

The Pond Lauriston Castle.

Lauriston Castle Pond

Lauriston Castle became the home of John Law, who served for a brief period as Comptroller General of France's finances under King Louis XV and was responsible for the Mississippi Bubble. The ornamental pond was a former stone quarry. Both grounds and castle are open to the public.

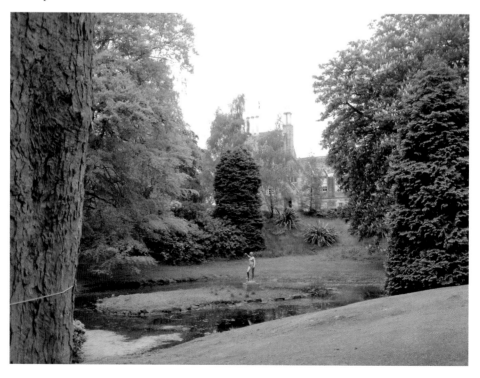

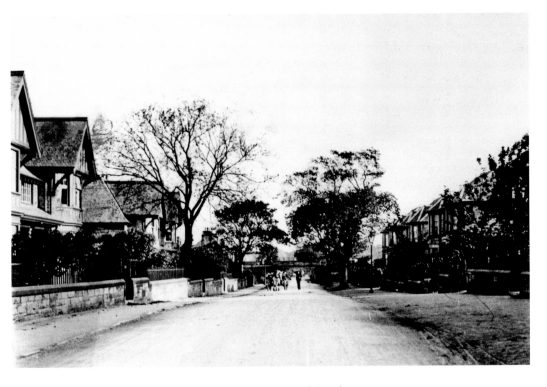

Continuing to Davidson's Mains via Cramond Road South

While horse traffic was normal at the time this postcard of Cramond Road South was printed, there is still the occasional horse and carriage to be seen. The Queen and King of Davidson's Mains Children's Gala are journeying towards their coronation, which is to be held in the field in Lauriston Castle grounds. Fortunately the day was conspicuous for its glorious weather, which isn't always the case.

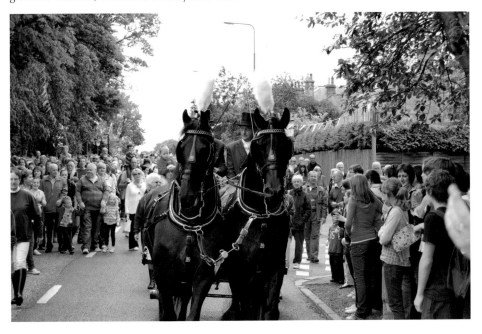

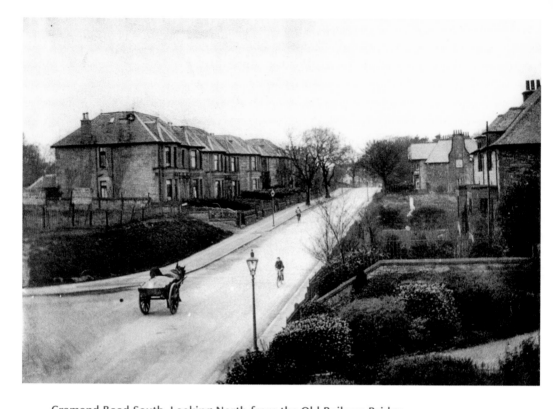

Cramond Road South, Looking North from the Old Railway Bridge
A house plot is still available at the corner of Cramond Road South, or Station Road as it was then known, and Barnton Avenue. The railway bridge from which this view was recorded was demolished, but a recent similar high level view shows a bungalow now on the site. The bunting is in aid of Davidson's Mains Children's Gala.

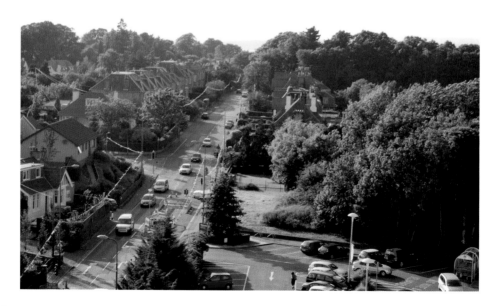

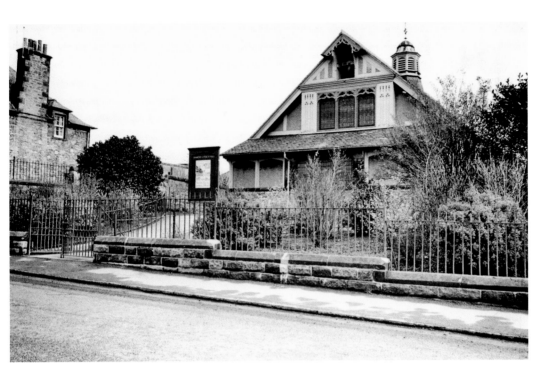

Cramond Kirk Hall, in Davidson's Mains

The erection of Cramond Kirk hall was funded by a grant from the Baird Trust and by Cramond Kirk Woman's Guild. The Guild was started in 1891, raising funds for various church activities including the erection of a suitable meeting place. They made and sold goods for use in missions abroad and clothing for staff in the surrounding mansions. When the hall was moved to Kirk Cramond, Davidson's Mains lost a valuable community asset. Smart's offices now occupy the site

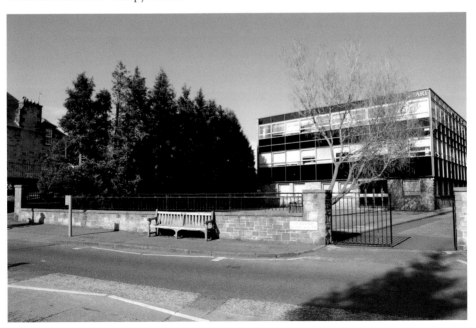

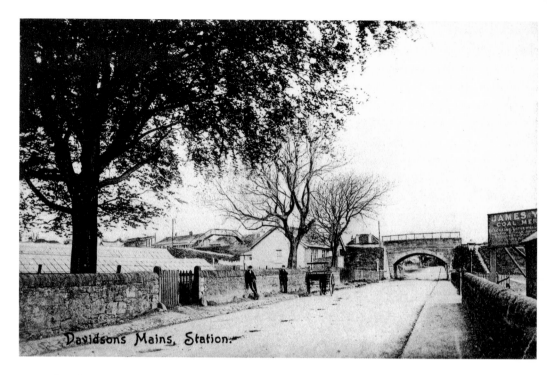

Davidsons Mains, Station.

The Changed Face of Cramond Road South

Davidson's Mains Station lay to the west of the railway bridge across Cramond Road South, convenient for golfers travelling to the Bruntsfield golf club. The station's position was one of the factors considered when the Bruntsfield Links Golfing Society was looking for a new home pending its move from Musselburgh. The club negotiated special terms for golfers with the railway company. The bridge, nursery and coal yard are long gone, the last two being replaced by housing and a supermarket.

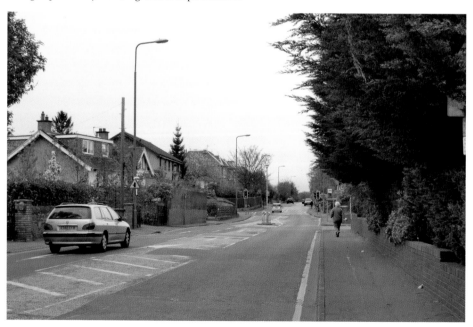

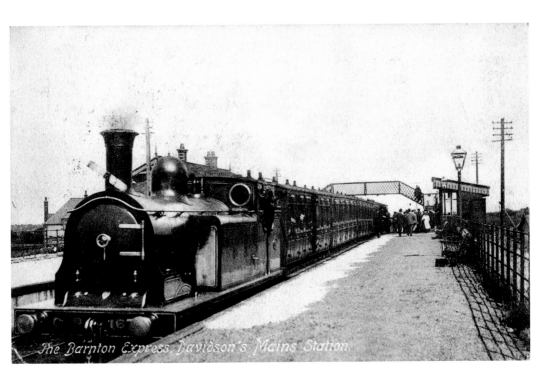

The Barnton Express. Davidson's Mains Station.

Public Transport to and from Davidson's Mains

The single track suburban service from Princes Street Station was extended from Craigleith to Barnton for passenger and goods traffic in 1894. The local schoolchildren were given a half-day holiday to celebrate the event. Here the Barnton Express is seen at Davidson's Mains Station, the stop preceding the terminus at Barnton, shortly after the line opened. Since the closure of the line to Davidson's Mains in 1960 Lothian Regional Transport now provides the passenger service.

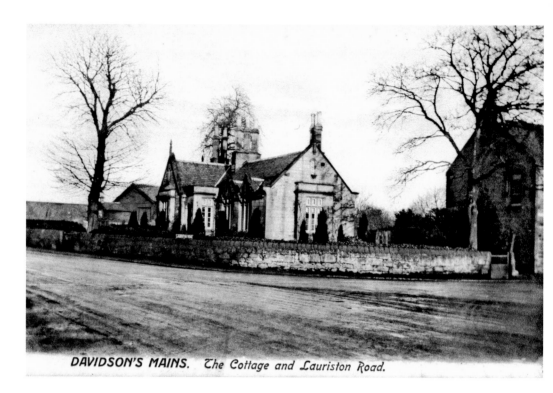

DAVIDSON'S MAINS. The Cottage and Lauriston Road.

Early Schools in Davidson's Mains

In the late nineteenth century, there were two schools in Davidson's Mains. Boys were schooled in the Free Kirk Hall, while girls were taught in the 'Lauriston School for Girls'. This was in the cottage on the site now occupied by the Royal Bank of Scotland. These schools eventually moved to new buildings in Corbiehill Road, becoming co-educational in 1893. One of the old trees remains between the bank and the first building in the Main Street.

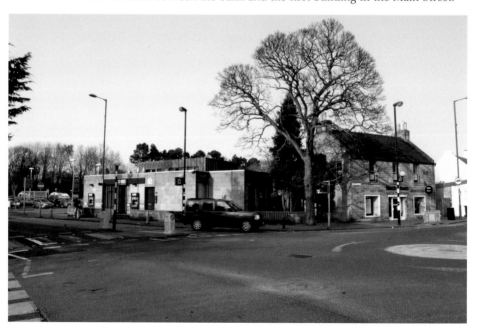

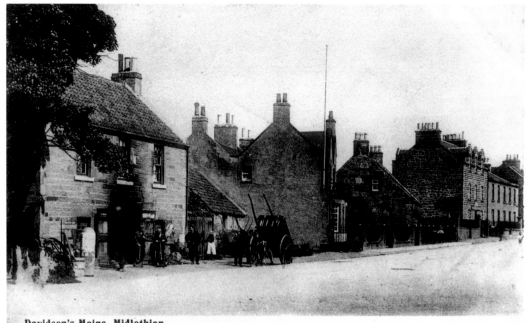

Davidson's Mains, Midlothian

The Village Blacksmiths

One of the village smiddys occupied pride of place at the end of the Main Street. Judging by its smoke-blackened wall its chimney must not have worked very well. A number of the early buildings remain despite the encroachment of late twentieth-century additions to the streetscape. The parade for Davidson's Mains Children's Gala is making its way to Lauriston Castle Grounds, the crowds lining the route attesting to its popularity.

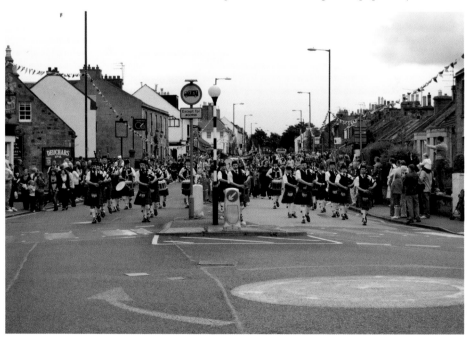

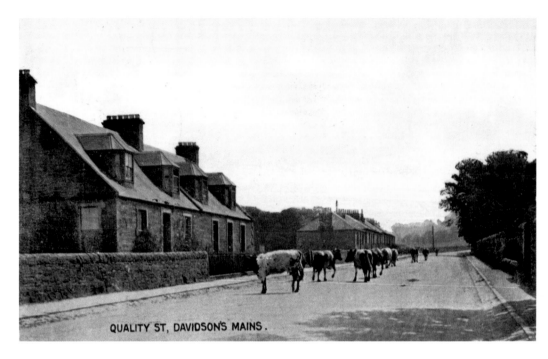

QUALITY ST, DAVIDSON'S MAINS.

Dairy Farms Surrounded the Village of Davidson's Mains

Quality Street occupies what was part of a byroad from Muttonhole, the old name for what is now the west end of the village of Davidson's Mains, to the road running along Ravelston ridge. Road traffic has changed considerably since the time when cows made their way to the village dairies twice daily for milking.

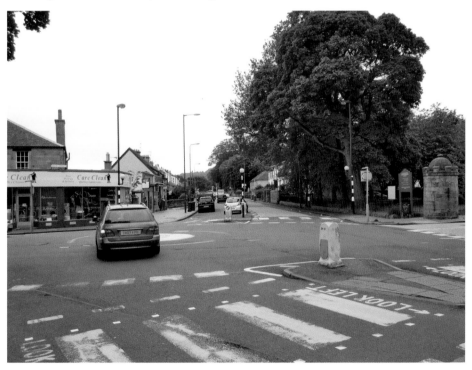

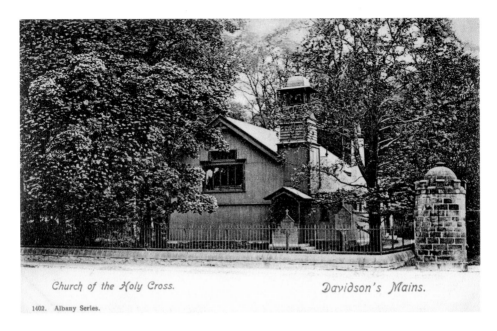

Church of the Holy Cross. Davidson's Mains.

1402. Albany Series.

Holy Cross Episcopalian Church

Episcopalian worship was initially conducted in Cramond Kirk hall, in Cramond Road South, then in rooms adjacent to the Old Inn. By 1898 their early corrugated-iron church had been erected. Ten years later it was decided to replace this temporary building with a more permanent stone-built place of worship. Benediction of the new church took place on 7 December 1913.

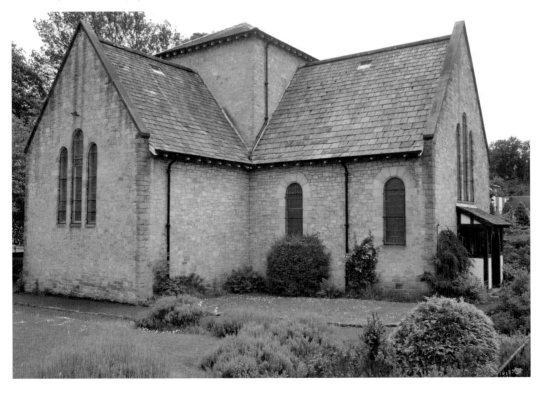

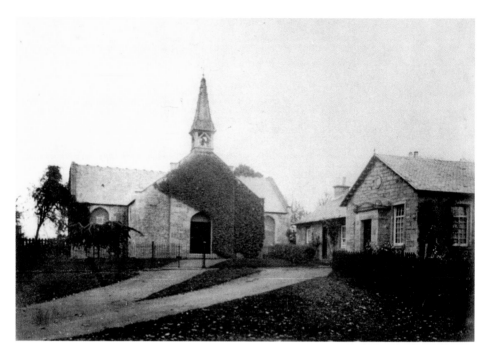

Davidson's Mains Parish Church

Following the Disruption of the Presbyterian Kirk in 1843, when the eighty-year-old Revd Doctor Muirhead led the congregation out of Cramond Kirk, services of the Free Kirk were divided between the old schoolhouse in Davidson's Mains, Fairafar Farm and a barn at Braehead. With the completion of this building in December 1843 the congregation was again reunited. Since then the kirk building has been joined by a beadle's cottage and two kirk halls.

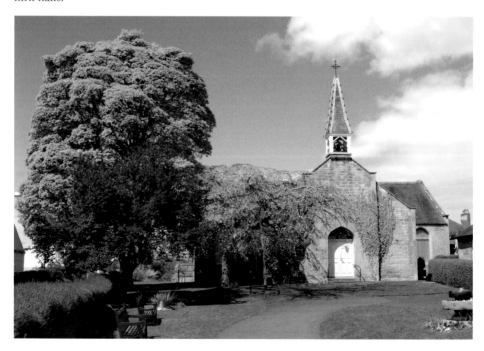

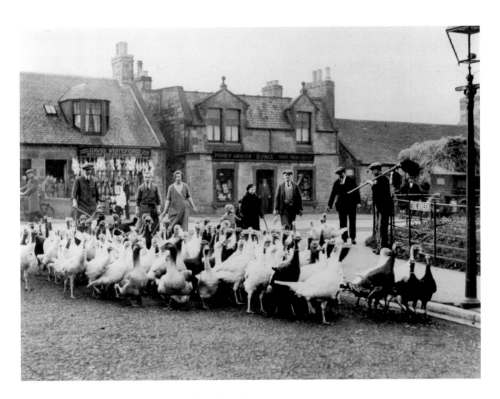

Main Street and the Green, Davidson's Mains

Christmas 1934, and geese and turkeys are nearing the end of their journey after arriving at Davidson's Mains Station *en route* to David Whiteford's butcher's shop, visible in the background. Despite Christmas Day not being a Scottish Holiday until the late 1950s, it was obviously celebrated in the normal way. The butcher's shop is now occupied by a florist.

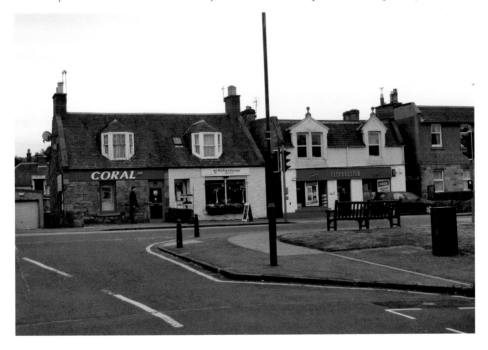

Saint Margaret's Roman Catholic Church

Catholic worship in the locality was initially held in the priest's house in Cramond, then in a cottage on Quality Street, due to the small number of Roman Catholics in the area. As their numbers increased, the first church was built by parishioners in the Main Street in the early 1900s. It remained in use until the current building was opened in 1953.

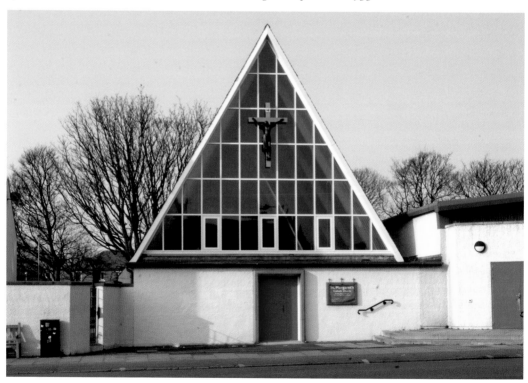

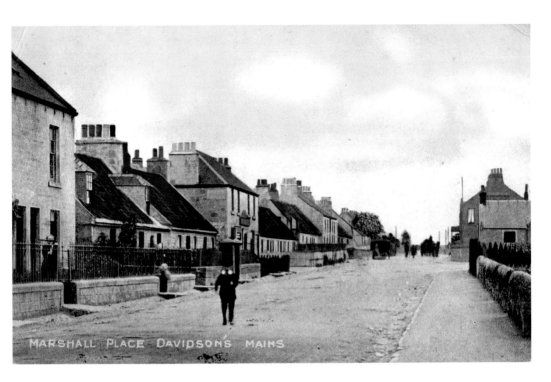

Main Street, Davidson's Mains

Marshall Place is an old name for part of the Main Street, from the time before Davidson's Mains was absorbed into the City of Edinburgh. This happened elsewhere as the city expanded; other examples are Whale Brae in Newhaven became an appendage to Newhaven Road and Glebe Road in Cramond became Cramond Glebe Road. In spite of the name change, a large number of the buildings are still recognisable in the recent photograph of what is now called Main Street.

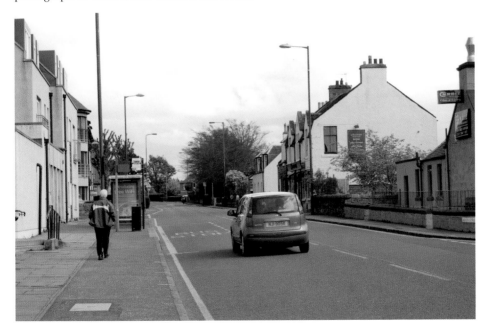

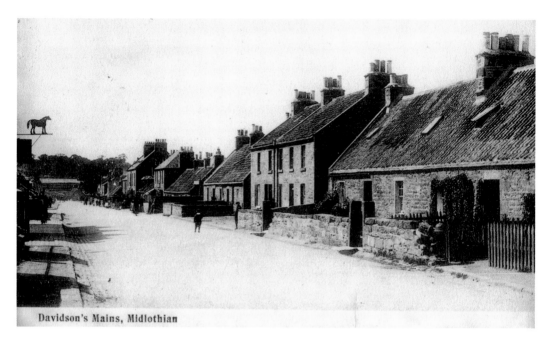

Davidson's Mains, Midlothian

Nicols' Midlothian Horse Repository

The horse sign jutting from the wall on the left is for Nicols' Midlothian Horse Repository. It was next to McKenzie's, formerly the Muirhouse Arms. Nicols' imported unbroken horses and then broke them to enable them to pull tradesmen's carts and vans. Local children regarded the spectacle of three or four horses being trained on the Main Street as better than a rodeo. The entire length of the street was needed to gain control of them, using a lunge rein and long whip.

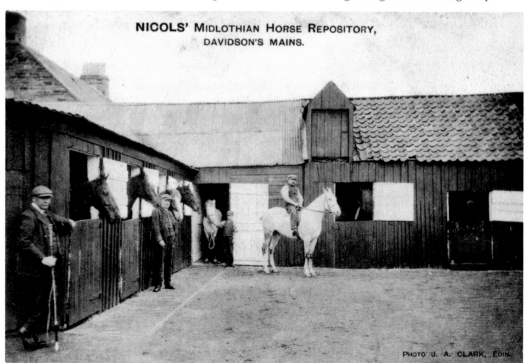

NICOLS' MIDLOTHIAN HORSE REPOSITORY, DAVIDSON'S MAINS.

PHOTO J. A. CLARK, EDIN.

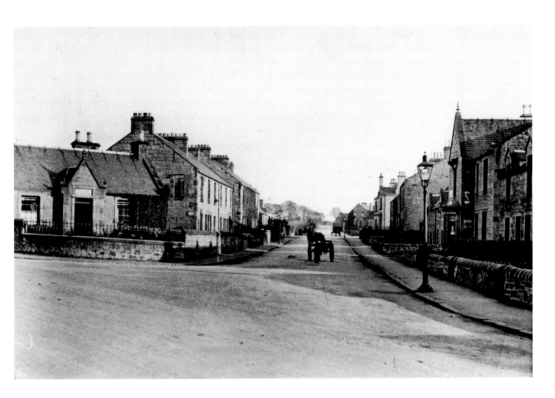

Davidon's Mains Police Station

The police station on the corner of Corbiehill Road has been replaced with 'The Corbie' fish-and-chip shop, and the street lighting no longer uses gas. The village school, visible at the top of the road on the right-hand side, has been replaced by a much larger modern building, adjacent to the original but set back from the road. Otherwise little has changed, although the traffic no longer supplies free fertiliser for the local gardens!

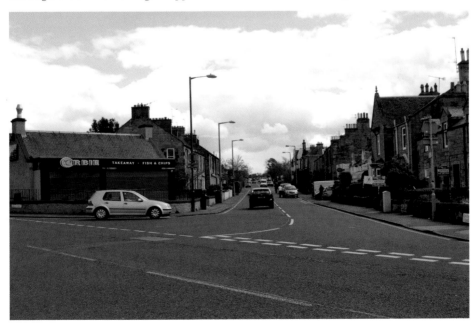

"Harvesting", Davidson's Mains.

Davidson's Mains Primary School, Corbiehill Road

Davidson's Mains Primary School, in Corbiehill Road, was built to accommodate the increasing numbers of pupils as the village expanded. The 1872 Education (Scotland) Act, which required all children aged five to thirteen years to be educated, also had an effect. The current school is no longer surrounded by open fields; it is now bounded by houses and can be easily identified in the recent photograph by the bright blue structures on its roof.

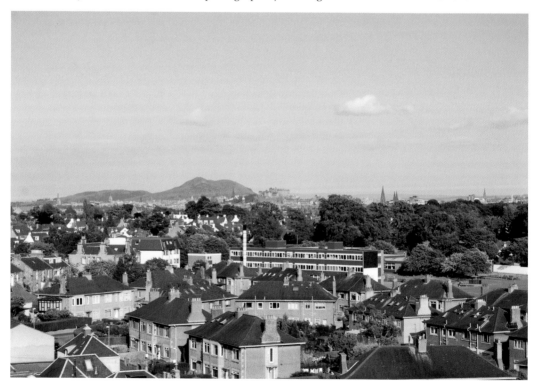

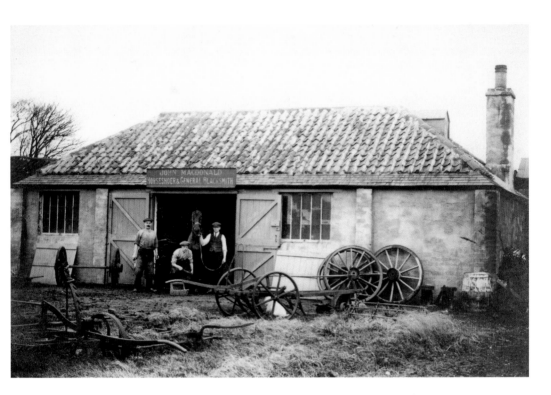

McDonald's Smiddy

This 'smiddy' was one of a number of such in the village which shod horses and manufactured and maintained agricultural ironwork for the local estates and farms. It lay to the west of Silverknowes Road, to the rear of Main Street. This short section of Silverknowes Road is no longer open to through traffic and its site has now been redeveloped.

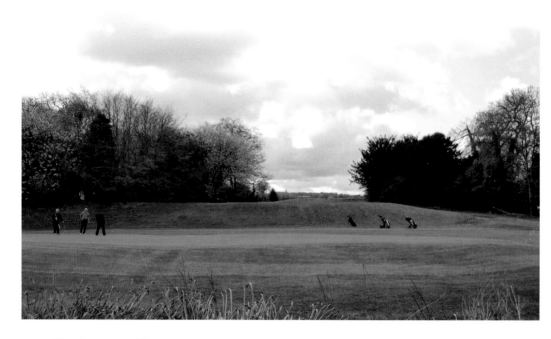

Silverknowes Golf Course

Silverknowes Golf Course opened in 1939 as a nine-hole public course on what had been part of Silverknowes farm. Play recommenced, after the Second World War, in 1956. The course was later extended to eighteen holes. Silverknowe [*sic*] House, where the ladies are seen playing croquet on what became the fifteenth green, was intended to be the clubhouse. It burned down in 1960 and was replaced by the current premises five years later.

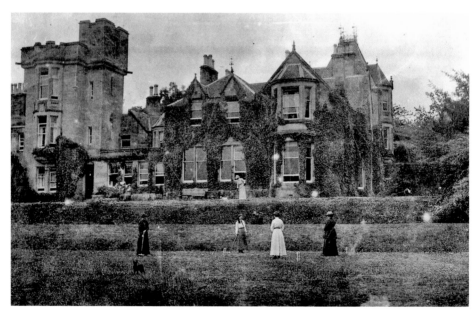

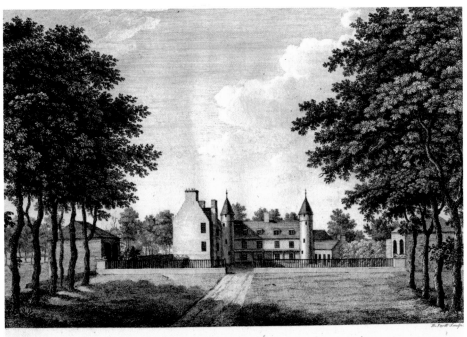

Muirhouse, in the County of Edinburgh, the seat of William Davidson, Esqr. taken from the east.

Muirhouse

The Davidsons, who in around 1850 owned Muirhouse, overlooking the Forth, renamed the nearby farming community of Muttonhole as 'Davidson's Mains'. As merchants in Rotterdam the Davidson family had amassed considerable wealth. By 1898 the property was in the hands of Henry Davidson, whose brother, Dr Randall Davidson, was Archbishop of Canterbury between 1903 and 1928. Muirhouse is now used as a shelter for the homeless.

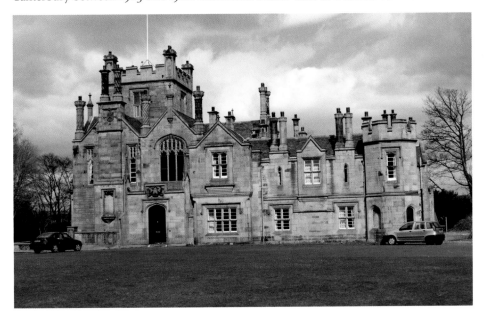

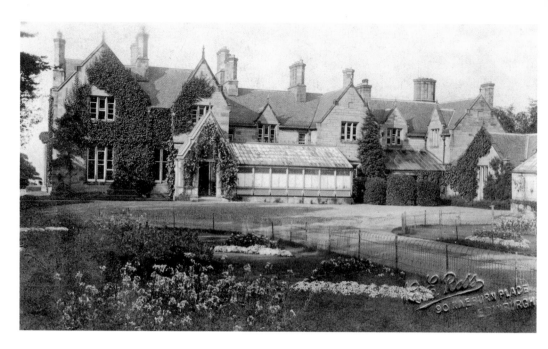

Broomfield

Broomfield was owned by the Haig family, whose whisky is well known to this day. It was visited by Field Marshall Sir Douglas Haig and Lady Haig in 1917. While they were travelling through Davidson's Mains the Field Marshall inspected a Guard of Honour made up of local servicemen, many of whom had been severely wounded in battle. The status of the house has sadly declined and it is now used for a similar purpose to Muirhouse.

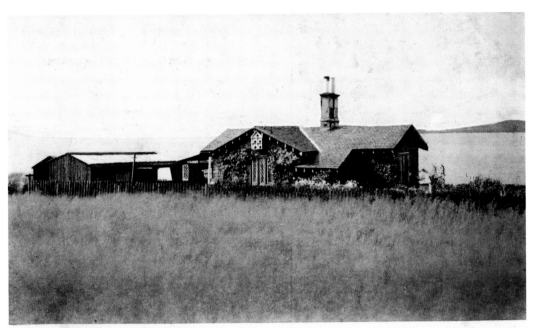

LAURISTON COTTAGE, CRAMOND BEACH.

Refreshments Beside the Promenade

Lauriston Cottage lay near the foreshore, at the end of a track leading from Lauriston Farm. It was run as a tearoom by the two Chalmers sisters but it closed after suffering from restricted access to the area during the Second World War. Its function has been replaced by the copper-roofed building on the promenade at the foot of Silverknowes Road.

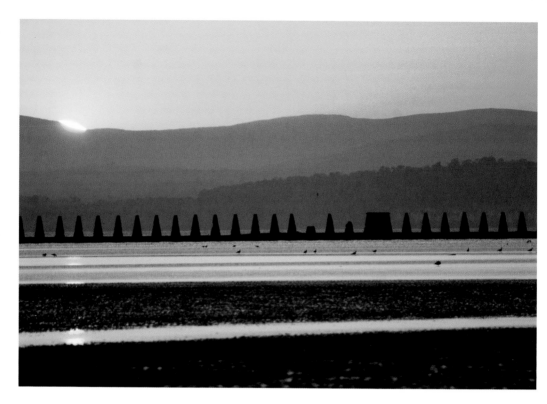

Foreshore
The wide expanse of foreshore between Granton Harbour and Houndpoint is an internationally important site for migrating seabirds and waders, providing rich feeding from the invertebrate life buried in the sand. With the sun setting behind the Lomond Hills, the remains of the anti-shipping barrier are thrown into silhouette and birds are starting to congregate to roost overnight.

Acknowledgements

The authors wish to thank Peter Scholes for enabling us to use samples from his extensive collection of old postcards of the area, and Cramond Heritage Trust for providing the remainder of the old photographs from their archive, with the exception of the early images on pages 8, 19, 65 and 70, which are reproduced courtesy of Edinburgh City Libraries (www.capitalcollections.org.uk); and that of the opening of the extended golf course on page 71, which was provided by the Bruntsfield Links Golfing Society. Recent photographs have been provided by John Dods, with the exception of those of the Roman lioness statue, which are courtesy of Val & Judy Dean; and the photomontage of the chain ferry, provided by Iain Eason.